The Complete
Drawing Course

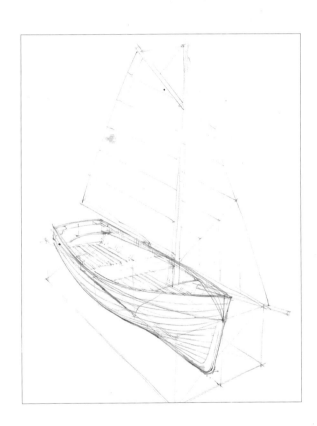

The Complete
Drawing Course

A comprehensive, easy-to-follow guide to drawing

JOHN RAYNES

BATSFORD

First published in Great Britain in 2002 by
Collins & Brown.

First published in paperback in 2008 by
Batsford
10 Southcombe Street
London
W14 0RA

An imprint of Anova Books Company Ltd

ISBN: 9780713490770

A CIP catalogue record for this book is available from the
British Library.

10 9 8 7 6 5 4 3 2

Colour reproduction by Classicscan, Pte Ltd, Singapore.
Printed and bound by Printed by Craft Print International Ltd,
Singapore.

Editorial Director: Roger Bristow
Design manager: Liz Wiffen
Project managed by Emma Baxter
Designed by Roger Daniels
Photography by John Raynes
Copy-edited by Ian Kearey
Indexed by Isobel McLean
Proofread by Mary Lambert

This book can be ordered direct from the publisher at the
website: www.anovabooks.com, or try your local bookshop.

Contents

What is Drawing?

What is drawing? Well, it is many things—the term has been stretched to encompass almost any marks made on a surface by human hand. It includes both the making of shapes and patterns that are totally abstract, and extends to marks that attempt to describe states of mind and concepts that exist solely in the imagination.

My intention in this book is to show how drawing is used as a means of discovering the appearance of the world and the objects and creatures within it, and also to describe ways of recording the shapes and volumes of those things by the use of line, tone and color in any and all mediums that may be available. In other words, my approach will be strictly visual.

Emphasis on the observable appearance of the real world does not simply create slavish, photographically real depictions. All drawings translate. Even drawing a line around an object involves a language, an understanding, that a line can represent the places where the surface of the object or figure turns away out of sight, which we call an edge. In reality, there is no line at the edge of an object, but we accept that by drawing a line there, the observer will understand that this represents the space that is occupied by that object. Even the earliest drawings known, on the cave walls of Stone Age man, use this linear outline language for drawings of animals. Human figures drawn on cave walls tend to be even simpler forms, with single lines

for limbs and torso, so-called stick figures. Similarly, we can draw lines to represent contours and sections that give information about volume and form, even without recording the light and shade that we normally rely upon, and the way that parts of a linear outline intersect can suggest the volumes that they enclose.

Why do this? Why not record every detail of color and tone? Well, sometimes it is interesting to put everything down, but there is also something fascinating about depicting reality with the simplest of means. Selecting one special aspect of your subject and emphasizing it above all others makes for a much more powerful and evocative drawing than one in which no feature dominates, that offers the observer no conception of the attitude and interest of the artist. For the same reason I like to see the unerased exploratory first marks underlying the final statements that give evidence of the progress of a drawing, the search for the most important elements. You may query the word "statement" applied to drawing, but it is used accurately because that is exactly what a drawing is doing: it is stating an observed fact, it is speaking to the

Linear patterns can be recognized as solid objects even when they show less familiar cross sections.

observer and saying "This is what I think this object is like," and also, perhaps, "This is what I find most interesting about it." Even within these fairly strict parameters, there is room for two somewhat different attitudes, two mind sets, when you approach a drawing. The first is one of complete concentration on the gathering of information, trying to see clearly, to gain knowledge of the subject purely objectively. The second is one in which, instead of only taking in, you give out, in response to that which you have discovered. In doing this you will be adopting a more subjective approach, allowing you to add or subtract or modify as you wish.

To some extent you can combine these two approaches by choosing to select some features of the object that you are drawing, and ignoring others. Discovering an object by looking at it would seem to be fairly straightforward, but for the tendency of the brain to modify what is seen. It does this subconsciously to translate what it deems to be nonsensical into more useful information. For example, a human leg viewed from the one end has a shape that more closely resembles a circle than the long, vaguely cylindrical shape that, from experience of other views, we know it to be. This is an example of foreshortening—it's not that it is difficult to draw, it is just difficult to see objectively. How do we get over the problem? Luckily, it is

The human brain has no problem deducing a solid form from a simple outline.

The brain recognizes this end-on view as a leg and transmutes it into the long object that it is, even though from this extremely-foreshortened view it is actually quite closely contained within a circle.

A less extremely-foreshortened leg may still be reinterpreted by your brain, but noting that it is almost completely enclosed by a square forces you to see it objectively.

quite simple—we impose checks and measurements that make sure that the brain's modifications are recognized and corrected.

The cover drawing illustrates the importance of observing what you see. The left-hand end of the verandah roof is visible, and assuming that this is in the same plane as the left-hand wall, why is it that the wall does not appear? The reason is that the wall is not in the same plane; in fact it meets the front wall at an acute angle, and consequently, when viewed from the front it slants out of sight.

This book intends to show you some of the more practical methods of seeing shapes and form and, having seen them, the much simpler job of rendering them in various drawing mediums.

LEARNING *to See*

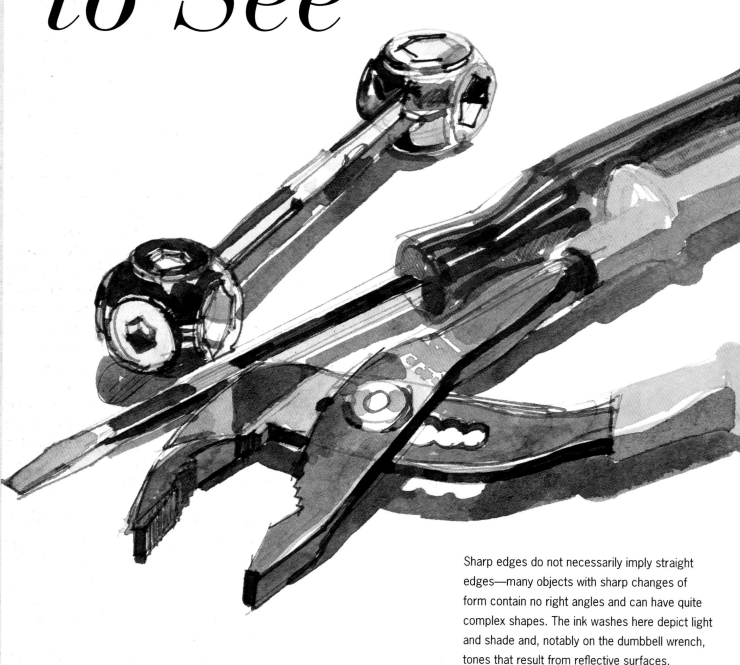

Sharp edges do not necessarily imply straight edges—many objects with sharp changes of form contain no right angles and can have quite complex shapes. The ink washes here depict light and shade and, notably on the dumbbell wrench, tones that result from reflective surfaces.

The biggest obstacle to drawing objectively is not being able to see what is truly there. It is not easy to shut off your brain's need to make your view more palatable or useful. For example, a ditch running across your view may be objectively very narrow, in that the front and back edge occupy very little space in the overall picture, but your brain says, "Ah, but the size of objects on the way to the ditch diminish, so previous experience tells me that the actual ditch will be much wider, maybe too wide to jump. We had better be cautious." In real life, this is a useful, maybe crucial interpretation, but it gets in the way of drawing objectively.

To combat this, you must measure and compare distances between the various elements of your subject. The well-known "outstretched arm with pencil and thumb" measuring method (see below), is as good a way as any of comparing dimensions. Second, use your inbuilt sense of the vertical to note how much upright elements of your subject deviate from this standard.

If you are not confident about your judgement of the true vertical, compare it with a known vertical, a door edge or similar. A plumb line, or even a pencil suspended loosely from your hand will guide you if there are no visible verticals.

The horizontal, as the name implies, is parallel to the horizon, and so are many man-made surfaces. We have a fairly acute sense of any deviations, so long as there is a true horizontal to compare against.

A viewing frame, divided into a regular grid of verticals and horizontals, is useful for judging deviations, and enables overall shapes to be more clearly seen.

Eventually you will acquire an inbuilt grid in your mind's eye that you can impose almost without conscious effort.

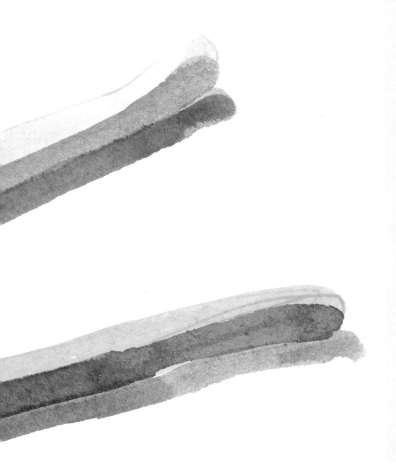

Hold a pencil or pen at arm's length to compare distances between the elements of the observed object. Keep your arm straight to maintain a constant distance between the pencil and the eye.

Cubes and Squares

The shape of solid geometric objects can be more clearly seen if you apply simple geometric figures to your view of them. Then, in turn, these solids can be used to help you to visualize more complex objects.

While many people find difficulty in assessing the length and direction of individual lines, almost everybody can judge whether a pair of lines are parallel to each other. We are also well able instantly to judge whether two intersecting lines form a right angle (90°) between them. Thus, with ease, a judgment can be made whether a square is truly square. There is a similar universal ability to make judgments about circles and triangles. We are sensitive to minute changes of angle and dimension when lines enclose a geometric shape, but randomly distributed lines of differing angles and length confuse us. So, before beginning to search for these shapes in real objects, you may like to experiment a little by covering a few sheets of paper with freehand drawings of simple outlines.

ORIENTATION
We are surrounded by references to the horizontal and the vertical, and they are the two most important concepts to have in your mind's eye when you look at a shape. Refer to the edges of the page or sheet of paper to judge the orientation of simple rectangles and squares.

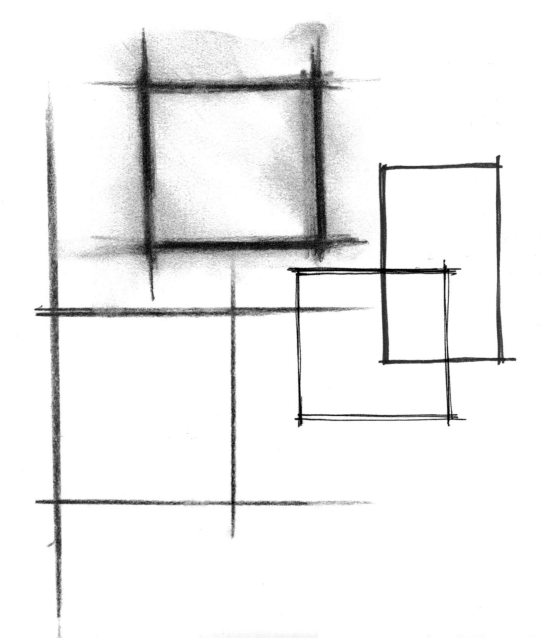

OFFSET SQUARES

These two offset squares suggest a cube, even though the "sides" are not yet present.

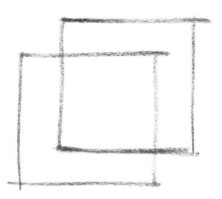

ILLUSION OF CUBE

By joining the corners an impression of solidity has been created. The perspective of such a figure is not really correct, but the eye is deceived into seeing a cube.

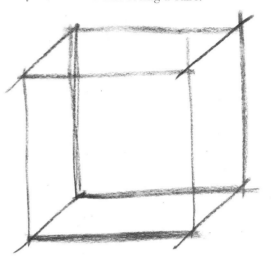

MAKING PYRAMIDS

The diamond shapes appearing at the top, sides, and base of the wire-frame cubes represent flat horizontal planes. The top one is drawn in red here. Erect a triangle (blue) on the base, and then rotate the apex a little to lean the triangle over. Join the apex to the other corners of the base to form a pyramid (green). It is unlikely that the pyramid will be symmetrical, but it will have the appearance of three-dimensional solidity.

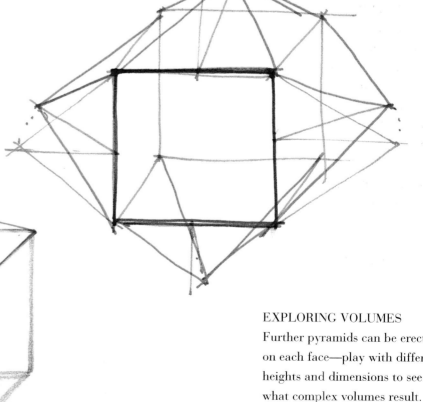

EXPLORING VOLUMES

Further pyramids can be erected on each face—play with different heights and dimensions to see what complex volumes result.

Chairs

These pages demonstrate ways of assessing and measuring shapes objectively without having any preconceived ideas about a shape and the relationship of one part to another.

SEE ALSO:

• Cubes and squares, page 12

• Sharp edges with tone, page 24

• Vanishing points, page 28

All objective drawing is about how you look at an object. Presented with a chair, what do you see? A more or less horizontal, generally approximately square-shape seat with perhaps a slightly off-vertical back and four vertical legs supporting the corners of the seat. This is what your brain interprets from the information supplied through your eyes—but what actually are you seeing? From most three-quarter views you will be seeing a series of diamonds and triangles, with not a square or a rectangle among them.

Putting the chair inside an imaginary box makes sense of this. The box structure shows you that the feet meeting the floor define a shape that reflects the perspective shape of the seat. Continuing the box upward allows any deviation of the seat back from the vertical to be judged, and the top of the seat back can be matched with one of the edges of the top of the box.

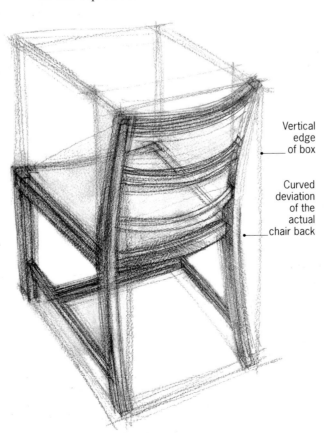

SIMPLE CHAIR
This chair has very few absolutely straight edges, so to work out its perspective it is helpful to imagine it contained in a regular box.

Vertical edge of box

Curved deviation of the actual chair back

Making a viewfinder

This is a useful way to assess shapes objectively. By holding the viewfinder in front of you and noting how the squares of your grid enclose your subject, you can assess whether it really is vertical, square or rectangular.

1 Cut a piece of card to 12½″ x 11″ (320 x 280mm), and mark a 8″ x 6¼″ (200 x 160mm) rectangle in the middle.

Make marks at 1⅝″ (40mm) intervals along all four sides of the inner rectangle, and extend these marks to the outer edge of the card.

2 Place the card on a cutting mat and, using a sharp utility knife and safety straightedge, cut out the central rectangle.

Cut slots about ¼″ (6mm) deep at each mark on the outer edge.

3 Knot the end of a thick, black cotton thread and slip it into the first horizontal slot. Bring the cotton across, loop it

through the opposite slot, and move on to the next slot. Continue until all horizontal slots have been threaded. Repeat on the vertical slots.

4 Cut a second piece of card to 13⅜″ x 12¼″ (340 x 310mm) and cut an inner rectangle the same size as that in the

first piece of card. You could use a mat cutter to make a neat bevel. Tape the two cards together.

FOUR-LEGGED STOOL

Even a stool with a circular seat and tapering legs has imaginary planes linking its feet and cross struts, while the ellipse that represents the seat is at the top of the box.

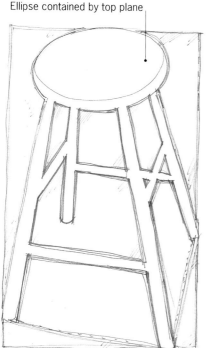

Ellipse contained by top plane

Use a rule if you find it difficult to draw the sides of your enclosing box, and check the directions by holding the rule up to your view of the object.

Another way to check that the structure of any object, but especially a chair or stool is correct is to look at the spaces left—the negative shapes—between the various components. If they don't match what you see, some of the structure must be wrong.

The point of devices such as these is to help you to see what's really there, and to counteract the tendency to draw individual components out of proportion to the whole.

GETTING THE SHAPE RIGHT

This stool is constructed with an arrangement of struts—note the shapes left between them. If the struts are wrong, little spaces, like the triangles seen center right, will disappear or be too large.

GETTING THE PERSPECTIVE RIGHT

The seat of this office chair has pivoted, so it helps to visualize the perspective shape of the casters on the floor and the "reflection" of the plane of the seat upon them.

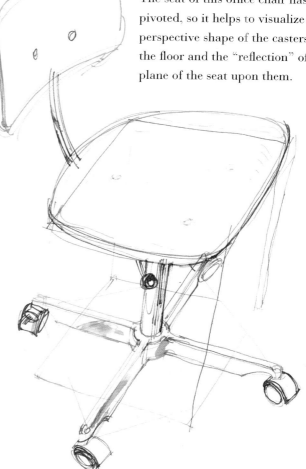

Vases and Flowers

SEE ALSO:

• Rounded forms in line, page 22

• Ellipses and cylinders, page 32

• Flowers in vase, page 74

In a similar way to visualizing a close-fitting, flat-sided box around an object, many objects can be perceived as being contained more closely by a cylinder or a sphere.

It may help your conception of this close containment to imagine yourself wrapping the object as a gift—a cardboard drum or tube may be the best way to enclose such an object snugly. Imagining and drawing such a containing shape, as with the boxes in the preceding pages, can help you to make sense of what otherwise may be a rather confusing collection of curves. This wrapping metaphor may seem to be less useful when it comes to determining the shape of something as delicate as a bunch of flowers that may be in the vase. But imagine the flowers to be made of ceramic or some other unbending material; the wrapping material would take on the overall shape of an otherwise amorphous form, thus providing a guide to the positions of at least the outer points of the bunch.

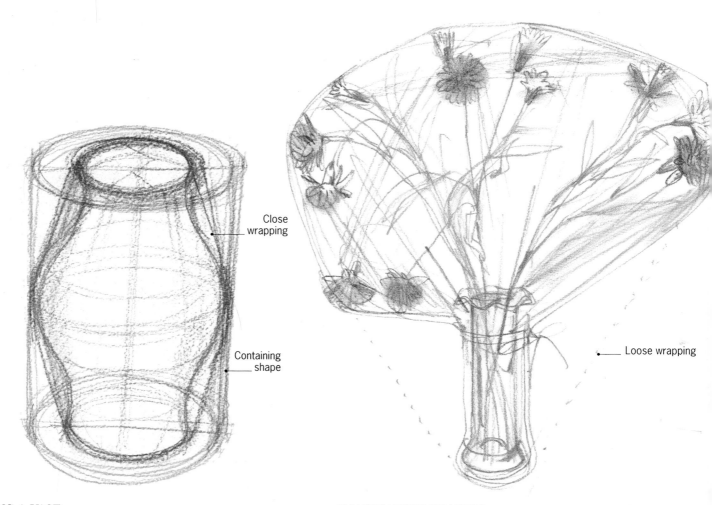

Close wrapping

Containing shape

Loose wrapping

FIXING A VASE

Imagine that you have to contain a double curvature vase like this in wrapping. A tube (drawn in orange) of the same diameter as the widest part of the vase, and of the same height will contain the shape and share the top and bottom ellipses. A closer wrapping is shown in red.

IMAGINARY PACKAGING

Adding a group of twigs or simple stems to the cylindrically contained vase makes it rather more difficult to judge the shape of the whole object, but imagining an enveloping package helps you to see its complete shape, and to proportion it more accurately.

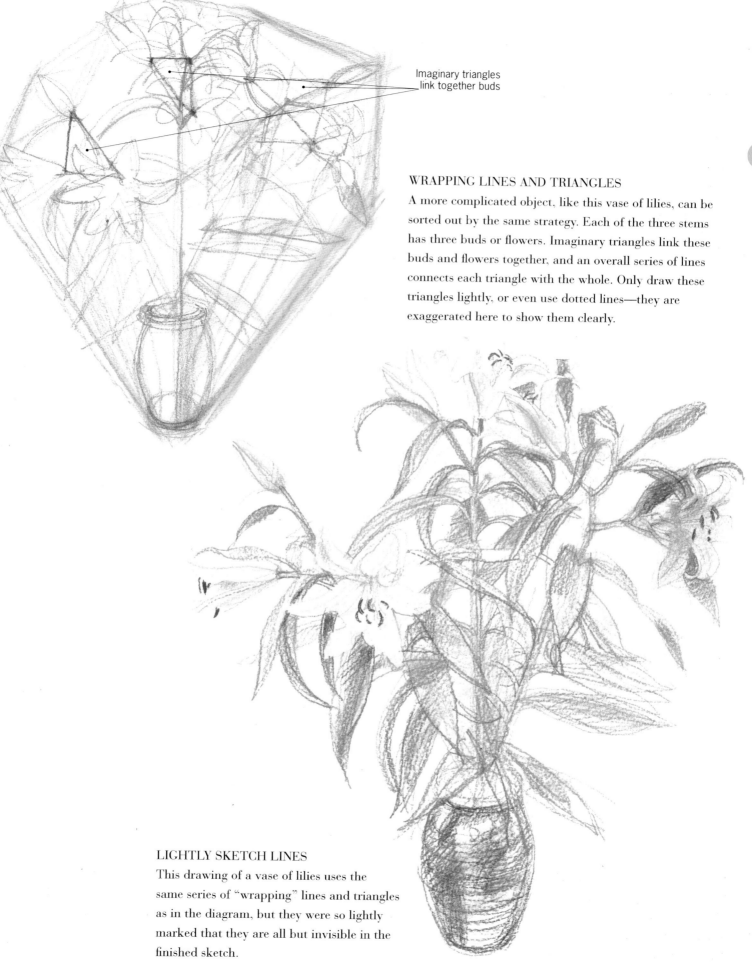

Imaginary triangles
link together buds

WRAPPING LINES AND TRIANGLES

A more complicated object, like this vase of lilies, can be sorted out by the same strategy. Each of the three stems has three buds or flowers. Imaginary triangles link these buds and flowers together, and an overall series of lines connects each triangle with the whole. Only draw these triangles lightly, or even use dotted lines—they are exaggerated here to show them clearly.

LIGHTLY SKETCH LINES

This drawing of a vase of lilies uses the same series of "wrapping" lines and triangles as in the diagram, but they were so lightly marked that they are all but invisible in the finished sketch.

Seated Figures

The difference between normal looking and the intense, objective observation needed to make a drawing is greatly accentuated when the subject is a human being.

SEE ALSO:

• Chairs,
page 14

• Vanishing points,
page 28

• Ellipses and cylinders,
page 32

In fact, in everyday social interaction we look at each other very selectively, noting subtle body language and expression with great precision and sensitivity, but completely missing the overall shape that must be central to an objective vision.

Although the human figure may seem to be a rather difficult subject to take on at this stage, I want you to become accustomed to looking at everything in terms of its undetailed, total shape.

SEATED ON A CHAIR

You will find it helpful when drawing a seated figure to think of the figure and its support as one shape. This is how a sculptor would treat the subject, "massing out" the complete volume from the ground up.

Extend center vertical through head

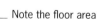

Note the floor area

THE FORM WITHIN

The individual shapes of figure and chair emerge from within the overall block.

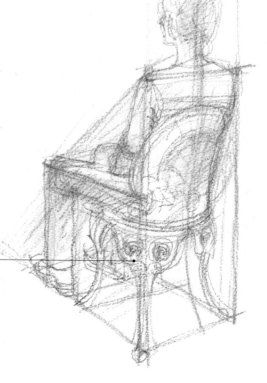

The shape of the chair is plotted with the overall framework

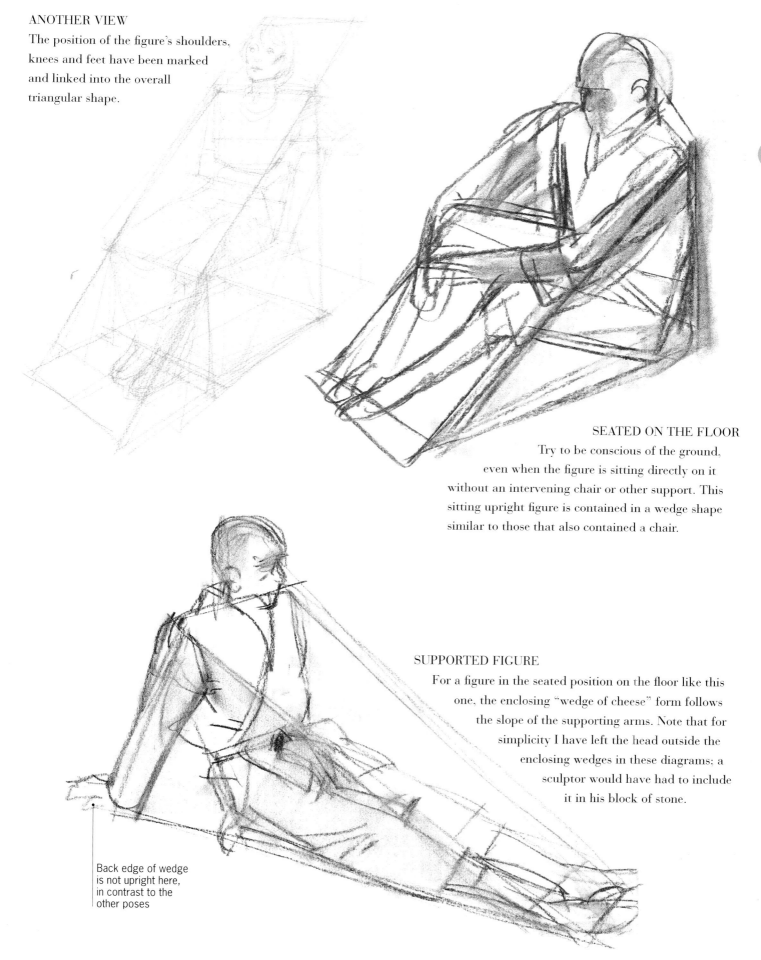

ANOTHER VIEW
The position of the figure's shoulders, knees and feet have been marked and linked into the overall triangular shape.

SEATED ON THE FLOOR
Try to be conscious of the ground, even when the figure is sitting directly on it without an intervening chair or other support. This sitting upright figure is contained in a wedge shape similar to those that also contained a chair.

SUPPORTED FIGURE
For a figure in the seated position on the floor like this one, the enclosing "wedge of cheese" form follows the slope of the supporting arms. Note that for simplicity I have left the head outside the enclosing wedges in these diagrams; a sculptor would have had to include it in his block of stone.

Back edge of wedge is not upright here, in contrast to the other poses

Sharp Edges in Line

We have seen how to represent volumes with lines that look like wire frames. The next stage is to look at various ways of using line to render a convincing impression of solidity.

SEE ALSO:

• Vanishing points, page 28

• Model boat, page 36

• Metal, page 58

The kind of feature that can be most easily described by the use of a single line is an abrupt change of direction between one flat plane and another that forms a positive edge.

By dotting and dashing and varying the weight and type of a line, much less obvious changes can also be depicted. For example, darker lines tend to bring edges forward, and lighter weighted lines seem to recede. You can create interesting effects by combining dark and light lines. For instance, if two lines intercept—one light and one dark—it appears that the form defined by the darker, uninterrupted line is in front of the shape defined by the lighter line. This sounds more complicated than it is in practice.

Try not to be self-conscious about these emphases—as you draw and feel your way around the forms, the marks you make should reflect your exploration.

CROSSING LINES

The principle of line crossing, described above, is clearly demonstrated in the areas ringed with orange here. The lines of the lower edges of the scissor handles seem to continue under the crossing lines of the upper edges; the impression is reinforced by making the upper edges somewhat bolder.

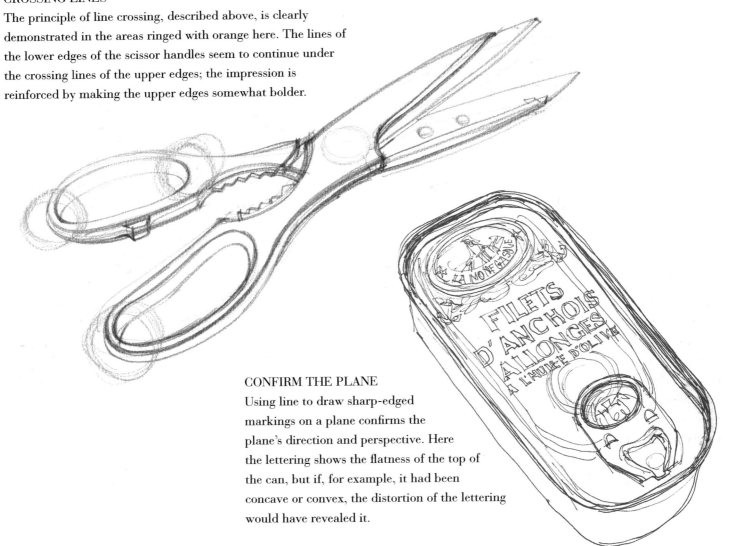

CONFIRM THE PLANE

Using line to draw sharp-edged markings on a plane confirms the plane's direction and perspective. Here the lettering shows the flatness of the top of the can, but if, for example, it had been concave or convex, the distortion of the lettering would have revealed it.

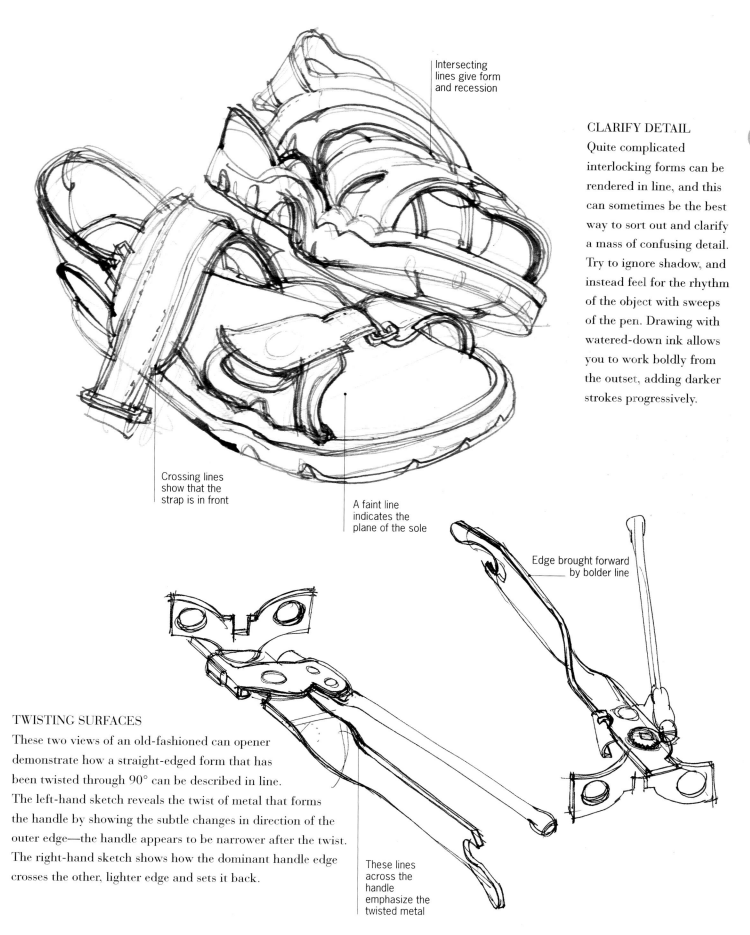

Intersecting
lines give form
and recession

CLARIFY DETAIL

Quite complicated
interlocking forms can be
rendered in line, and this
can sometimes be the best
way to sort out and clarify
a mass of confusing detail.
Try to ignore shadow, and
instead feel for the rhythm
of the object with sweeps
of the pen. Drawing with
watered-down ink allows
you to work boldly from
the outset, adding darker
strokes progressively.

Crossing lines
show that the
strap is in front

A faint line
indicates the
plane of the sole

Edge brought forward
by bolder line

TWISTING SURFACES

These two views of an old-fashioned can opener
demonstrate how a straight-edged form that has
been twisted through 90° can be described in line.
The left-hand sketch reveals the twist of metal that forms
the handle by showing the subtle changes in direction of the
outer edge—the handle appears to be narrower after the twist.
The right-hand sketch shows how the dominant handle edge
crosses the other, lighter edge and sets it back.

These lines
across the
handle
emphasize the
twisted metal

Rounded Forms in Line

Rounded objects with gradual changes of form offer no positive edges for you to pick up with a line, so you must find other ways to render them solid by the use of line.

SEE ALSO:

• Ellipses and cylinders, page 32

• Teapot, page 34

• Fruit and vegetables, page 82

One of the best ways to capture rounded forms in line is to delineate the places where light and dark areas meet, without giving those areas any real shading. You are trying to designate the line on a curved surface where it turns away from the light source and into shadow. Of course this line of change is only available if the object is lit mainly from one side (or strongly from two sides with light of different colors), and it is not always identifiable as a line, rather a soft-edged band where the object is neither fully in light or fully in shadow.

You can give an object apparent solidity by using your sense of three-dimensional vision to imagine and draw lines that travel round the form as if they were strings tied around the object. This method can be used when there are no strong light-and-shade areas detectable. It is rather similar to the use of contour lines on a map that can be "read" as descriptions of hills and valleys.

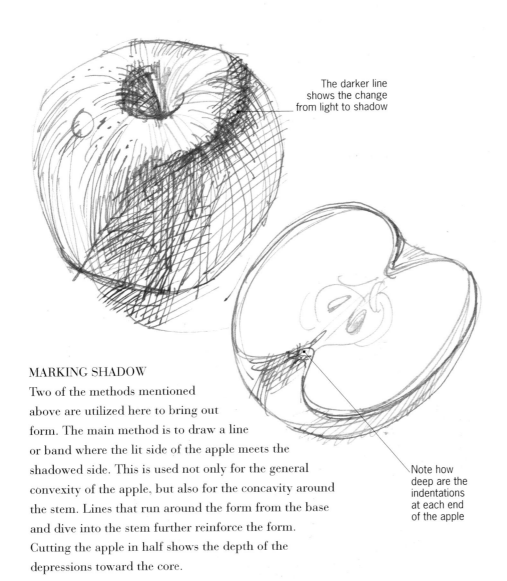

The darker line shows the change from light to shadow

Note how deep are the indentations at each end of the apple

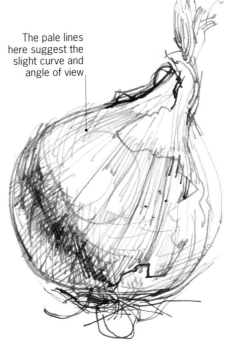

The pale lines here suggest the slight curve and angle of view

MARKING SHADOW

Two of the methods mentioned above are utilized here to bring out form. The main method is to draw a line or band where the lit side of the apple meets the shadowed side. This is used not only for the general convexity of the apple, but also for the concavity around the stem. Lines that run around the form from the base and dive into the stem further reinforce the form. Cutting the apple in half shows the depth of the depressions toward the core.

STRUCTURE IN LINE

Like the apple on the left, the light/shadow division curves across the form of this onion, and the natural structure provides "longitudinal" lines from top to bottom.

CROSS SECTION FOR FORM

In common with other long fruit and vegetables, zucchini have a pronounced series of flat forms running along their length. Cutting across the form shows a cross section with up to ten sides. five of which you can define on the outside.

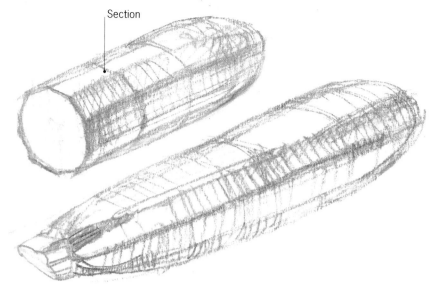

Section

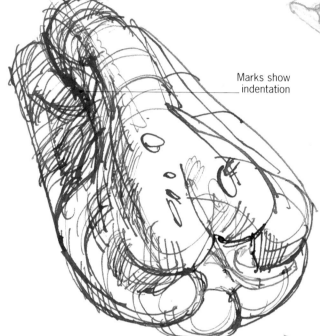

Marks show indentation

INTERPRET FORM WITH LINE

Again. the light/dark change has been traced, but more use is made of lines around the form as though they were cut lines through the bell pepper, and near-circular contours drawn on the bulbous ends near the stalk. Any device can be used to make clear what the shape and form truly are, regardless of whether the marks drawn exist on the surface in reality.

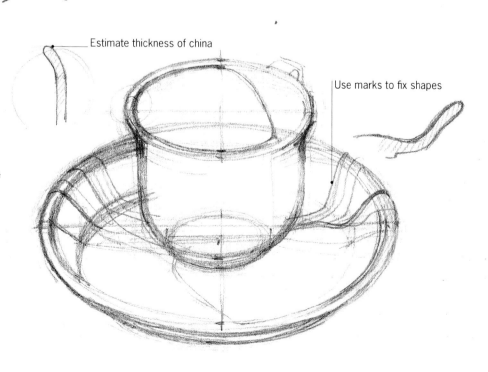

Estimate thickness of china

Use marks to fix shapes

ESTIMATE CROSS SECTIONS

Ellipses, which will be considered in more detail later. are essentially cross sections of the cylinder of the cup, in just the same way are cuts through the apple or the zucchini. Follow the principle of describing the form with any marks that help—even separately estimated cross sections of the thickness of the china. or feeling material with the fingertips.

Sharp Edges with Tone

Adding tone to your repertoire of drawing marks allows you to make a more realistic rendering of the fall of light. It should differ from a photograph because the human eye can see three dimensions.

It is possible to render convincing solidity by the use of tone alone, dispensing with line, but a combination of the two works well and can often be a more economical solution.

If you decide to use just tone without line, you must define edges by changes in the tone. It may then be necessary to draw some background to your main subject, If you look closely, you may find that an edge that appears quite dark where it impinges on a light background will appear to be considerably lighter where the background is dark. Make maximum use of these contrasts, but where you can see no difference in tone between subject and background, be prepared to leave the edge to "float."

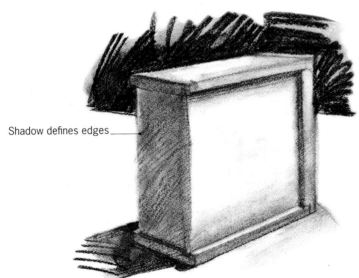

Shadow defines edges

CHANGES OF TONE

This simple wooden drawer standing on one of its sides typifies a straight-sided solid object, lit strongly from one side. The edges are shown not as lines, but as changes of tone. Charcoal is good for this type of study because it can be readily changed, using a soft putty eraser as a means of modifying or eradicating the tonal areas.

TONAL VARIATIONS

Looking into the drawer introduces more complexity to the pattern of tones. The cast shadows are sometimes darker than the form that casts them, and the same edge may appear light against dark in one area, and dark against light further on, as on the back edge.

CATCHING THE LIGHT

The various directions of the raised moldings of the drawer front catch the light differently—the vertical ones are shadowed much in the same way as the side of the drawer, while the horizontals pick up the same light as the top edge.

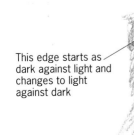

This edge starts as dark against light and changes to light against dark

This edge needs no further definition

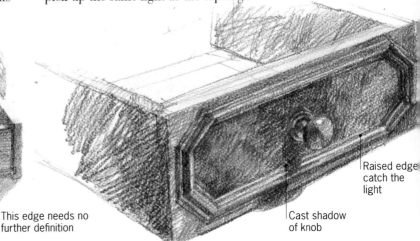

Raised edge catch the light

Cast shadow of knob

EXPERIMENTING WITH TONE

An object like this puzzle, with a number of planes all facing in slightly different directions, is ideal for practicing tonal variations. The complete star-like object could be disassembled into six parts that are themselves interesting and challenging to draw. Such unfamiliar forms as these are difficult to render unambiguously, so, as well as making purely tonal drawings, try to clarify them by combining line with partially-invented tone. Don't be too fixed in your choice of method or medium.

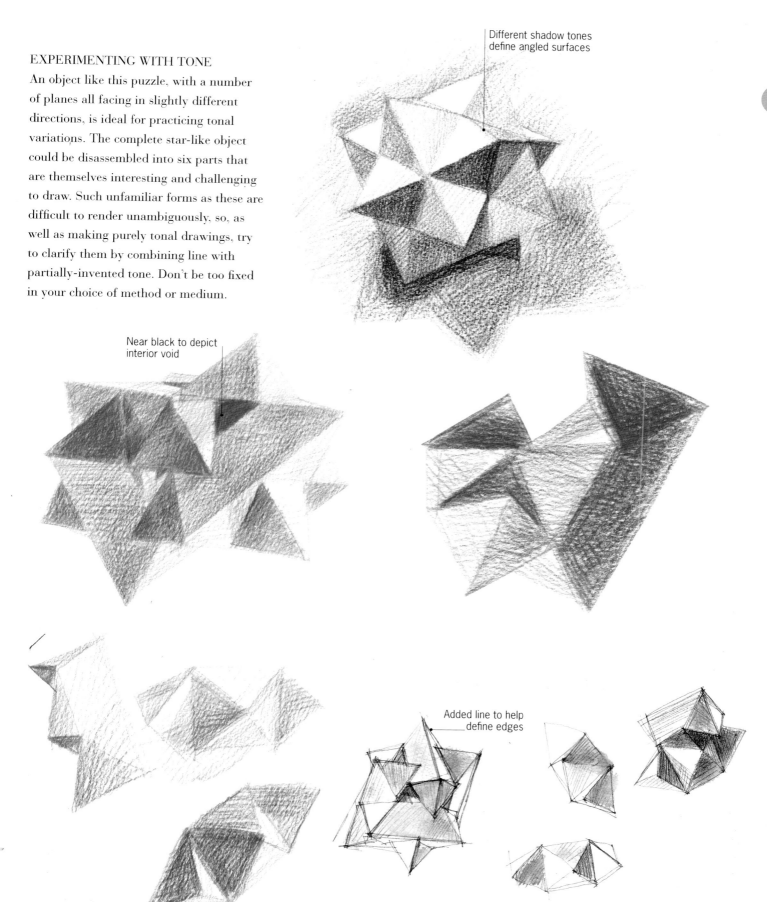

Different shadow tones define angled surfaces

Near black to depict interior void

Added line to help define edges

Rounded Objects with Tone

For objects with sharply defined edges between their main planes the tonal changes are clear-cut. Finding the same transition on curved surfaces requires close observation of the significant tonal changes.

SEE ALSO:

• Rounded forms in line, page 22

• Strong, direct light, page 44

• Fruit and vegetables, page 82

The advantage of seeing in 3D gives you the chance to use light and shade in the best way to show form; however, this is not necessarily an exact copy of the existing pattern of light and shade. It rather depends on what you are searching for in a particular drawing. When, as here, the search for form and solidity is the primary objective, then it may even be beneficial to invent tone that is not actually visible, in order to describe the form more explicitly. Similarly, the precise level of tone in a shadow need not match reality—it is more important to look at the *shape* of the tonal areas when searching for form.

Just as you searched with line for that special demarcation where a curved form turns away from the light into shadow (see pages 22–23), you can use tone to do the same thing; it just requires you to make slightly different marks. In fact, the area that shows where a curved surface turns away from the light is often less a line than a soft-edged band, where the form receives light from neither the principal light, nor the reflected light that normally re-illuminates the shadow side. As such, it is probably easier to search for the form, and to record its shape with softer marks than it is to render it in line. Be careful to avoid being too nebulous and imprecise— it is the exact nature of the twists and turns of this demarcation that reveal the presence of flats and hollows or any other variations in the curvature of the form.

STRONG SUNLIGHT
The definition between lit and shadowed areas is often very sharp in strong sunlight, even though the forms have very few sharp edges.

OUTLINE WITHOUT TONE

An egg is such a familiar ovoid form that the outline alone will probably be enough to identify it. For a more tangible impression of solidity, it will need some tone.

BAND OF TONE

Probably the simplest way to depict the ovoid form is using a simple linear outline, with the main change from light to dark shown by a band of tone. Though this band needs to be soft-edged, it should not be vague. In this case, the band is almost straight.

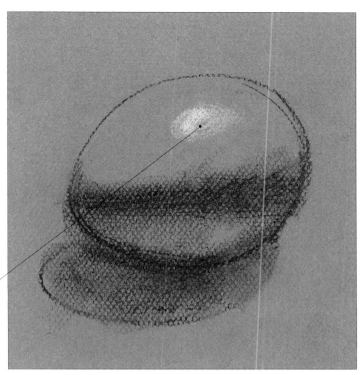

Reflected highlight completes the impression of solidity

TONE WITHOUT OUTLINE

A more complete rendering of the form of the egg can be made by applying tone over the whole surface and dispensing with the outline altogether. The slightly raised viewpoint here has made the demarcation between light and shade more curved.

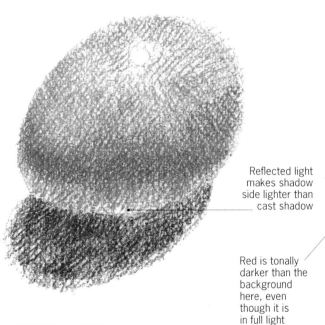

Reflected light makes shadow side lighter than cast shadow

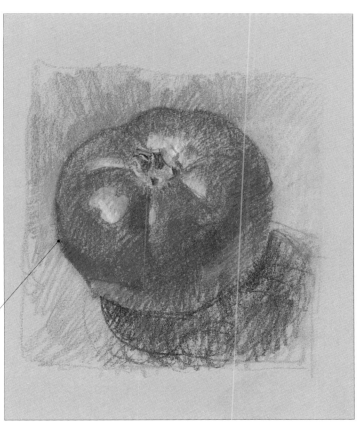

Red is tonally darker than the background here, even though it is in full light

CHANGES OF TONE AND COLOR

As with sharp-edged objects, you can take tonal rendering a step further: the immediate background to the object can be indicated, thereby defining its outer limits. As before, look carefully at the way some edges are defined as light against dark, and others the reverse. Color adds an extra element of possible contrast, so even where the edge of the object and its background are very close tonally, a color change may make the transition obvious.

Vanishing Points

SEE ALSO:

- Leading the eye, page 40

- Townscape, page 120

- Uphill street, page 128

Perspective is the name given to a series of fundamental observations that have been organized into "rules" that help to explain how objects appear smaller as their distance from the observer is increased.

The modern system of measured perspective has now become very comprehensive, to the extent that if you have full working drawings and plans, even quite complex structures can be rendered with great accuracy as they would appear in the solid.

Understanding the complex procedures used in these projections, however, is not necessary when the subject of your drawing is there in front of you. Indeed, if your powers of objective observation were absolutely impeccable, you would have no need of any

of these rules. But most of us can use a little help when it comes to sorting out just what we are actually seeing through our eyes, especially if what we are seeing is a view as challenging in terms of perspective as, for example, a downhill street.

Knowing the simple fact that horizontal lines appear to converge at the horizon, and with just a few extensions of that rule, a bewildering series of directional lines of roof tiles, window ledges, doorsteps and so on will fall into place and make sense.

Single-point perspective

LOW HORIZON

First, decide where to draw the horizon, the line where the earth meets the sky on a flat plain or over the sea. If you are looking up to include more sky, the horizon will be low in your view

HIGH HORIZON

If you are looking down, the horizon will be high.

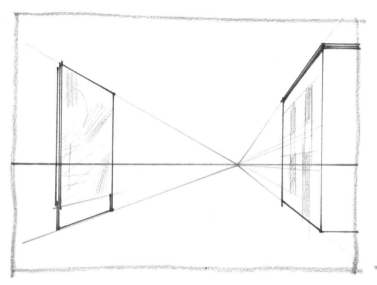

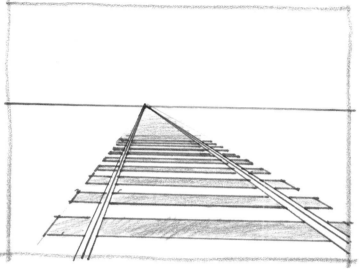

VANISHING POINT

The horizontal edges of a vertical shape, such as a billboard or the front of a house when viewed almost end-on, will appear to converge toward a point on the horizon. Thereafter, all the other horizontal features on that surface will "vanish" to the same point.

DIMINISHING RAILROAD RAILS

The same principle applies to parallel lines on the horizontal plane—everyone is familiar with the way that rails converge as they disappear into the distance.

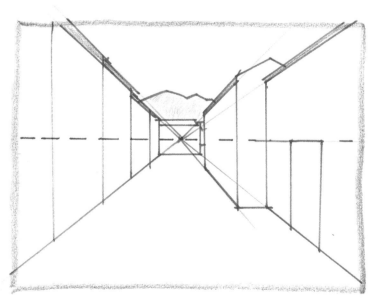

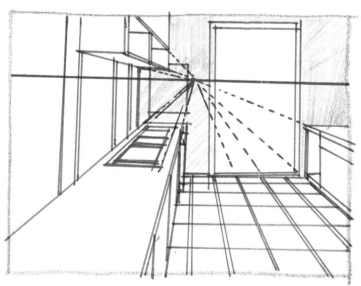

HIDDEN HORIZON

The plane of the earth is not really flat, of course—it curves gently away out of sight, but for the purposes of perspective we treat it as being flat, and the horizon is where this flat plane meets the sky. If buildings or mountains obscure your view of the horizon, you can discover where it is by finding two or more horizontal elements in the foreground and projecting them until they meet.

INTERIOR

Remember that the same rule applies indoors to cupboards, doors, tabletops and so on, even though you may not be able to see the horizon through them.

Measuring distances

Looking again at the railroad line on page 29, you will see that the ties (sleepers) appear to be set closer together as they get smaller. It is quite easy to calculate just how much these spaces diminish as their distance away from your eye increases.

All you need to know is one extra fact. If you draw the diagonals of a square or a rectangle, the point where they cross defines the middle line in both directions, so that the farther smaller half and the nearer larger half are both exactly the right sizes in perspective for that particular situation and vanishing point.

This is very useful, because once you have achieved two receding rectangles, you can continue to project others backward into space (and forward, too).

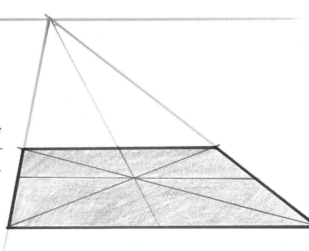

BISECTING IN PERSPECTIVE

All equal divisions diminish in perspective in the same way as railway ties (sleepers). To enable you to measure this effect, first draw two horizontal lines and two vanishing lines representing the space you would like to repeat.

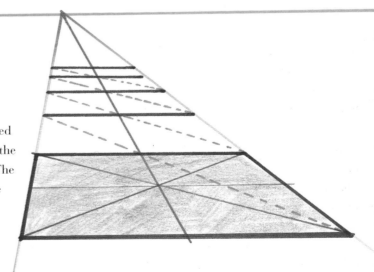

PROJECTING INTO THE DISTANCE

Next draw a line through the crossing point of the diagonals to the vanishing point. This bisects the rectangle the other way. If you then project a line through the halfway point to the far side (green dotted line), its intersection with the vanishing edge marks the point from which you can draw the next rectangle. The green dotted line is now the bisecting diagonal of the two combined. By repeating this maneuver, you can find the next rectangle, and so on into the distance.

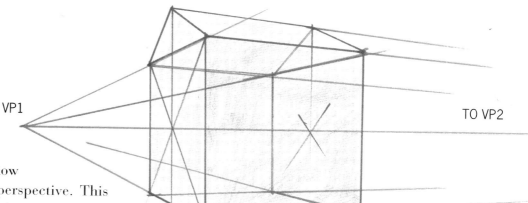

Two-point perspective

All the preceding diagrams show what is called single-point perspective. This assumes that the planes running across your vision are unaffected by perspective so that their parallel lines do not converge. In fact this is almost never so—any variation from the absolutely straight-ahead view will produce some convergence.

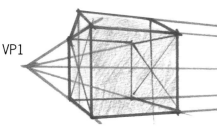

DISTANT VANISHING POINT (VP)

The second vanishing point (VP2) may be so far away as to be well out of your picture area, in which case you must either project to this point with a long rule, or make your judgement by eye.

TWO-POINT PERSPECTIVE

These less extreme converging lines meet at the second vanishing point (VP2), and the system is therefore known as two-point perspective.

Three-point perspective

In most situations we can treat uprights as being vertical with no convergence; only when the uprights describe very tall structures will you see the verticals converging. When this occurs, there is a third vanishing point (VP3).

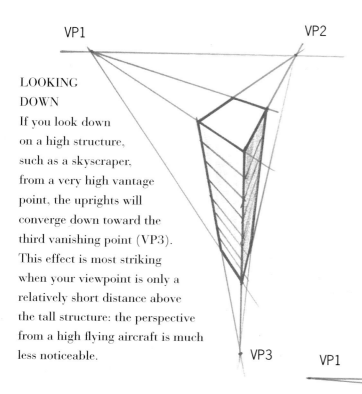

LOOKING DOWN

If you look down on a high structure, such as a skyscraper, from a very high vantage point, the uprights will converge down toward the third vanishing point (VP3). This effect is most striking when your viewpoint is only a relatively short distance above the tall structure: the perspective from a high flying aircraft is much less noticeable.

LOOKING UP

If you you need to tip your head and look up to such a structure the third vanishing point (VP3) will be in the sky (the base of the building will be out of view, as shown by the blue circle). To see the whole building in one view you would need to be farther away and then the convergence of the verticals would be much less extreme, or even undetectable.

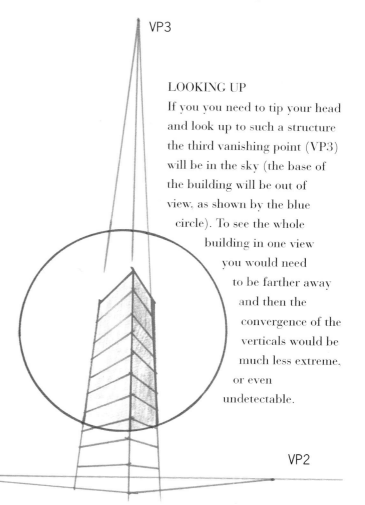

Ellipses and Cylinders

A circle seen in perspective is an ellipse. If your view of a circular disc is near your eye level the resultant ellipse will be rather thin, and as your eye level rises or lowers it becomes increasingly fatter.

SEE ALSO:

• Rounded forms in line, page 22

• Lawn Mower, page 38

• Bicycle, page 92

You might expect that, as the more distant half of a rectangle in perspective appears smaller than the near one, the same would apply to the circle in perspective. Indeed it does, but it doesn't look like this because its two differently shaped halves combine to make a perfectly symmetrical whole.

The line dividing this symmetry along its longer length is called the major axis, and it is slightly displaced from the perspective halfway line, as you can see in the diagram below. The shorter width is the minor axis, and this always forms a right angle with the major axis, a fact that has particular relevance to the appearance of ellipses when they appear as wheels or sections of cylinders.

A true ellipse can be mathematically defined and constructed by various means, but with practice you soon learn to recognize the flowing, non-pointed shape and to draw it freehand.

To emphasize the correct shape of ellipses, I drew them with aid of ellipse templates in the first four colored drawings shown here.

CAPTURING AN ELLIPSE

The rear half of the circle in perspective is contained in the rear half (colored pink) of the surrounding square, and the nearer, rather differently shaped half (colored green) fills the larger near half of the square. Remarkably, the combined shape forms this absolutely symmetrical oval shape, an ellipse, the blue line being the major axis.

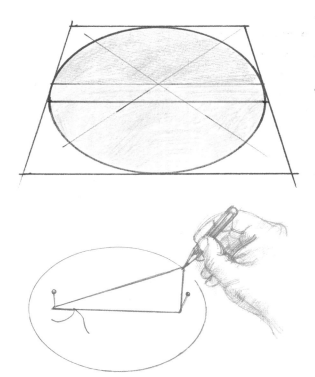

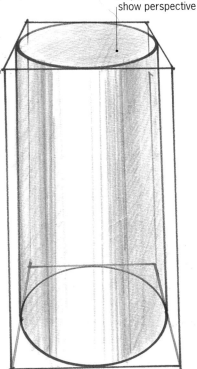

Ellipse is flattened to show perspective

USING PINS AND THREAD

Place two pins 2½″ (6cm) apart. Tie a circle of thread, loop it around the pins, and stretch the thread taut in any direction with a pencil point. Keeping the thread taut, draw around the two pins—the resulting shape is an ellipse. Varying the length of the thread and the distance between the pins produces different types of ellipse.

PERSPECTIVE ON AN ELLIPSE

Just as a tall wire frame box seen from slightly above shows more of the base than the top, so a similarly seen cylinder will have a fatter lower ellipse than the one at the top.

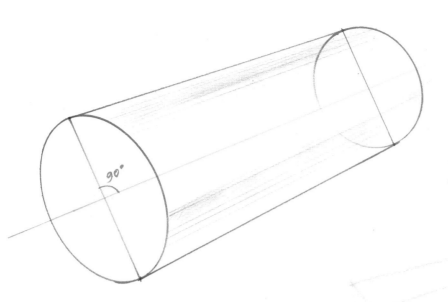

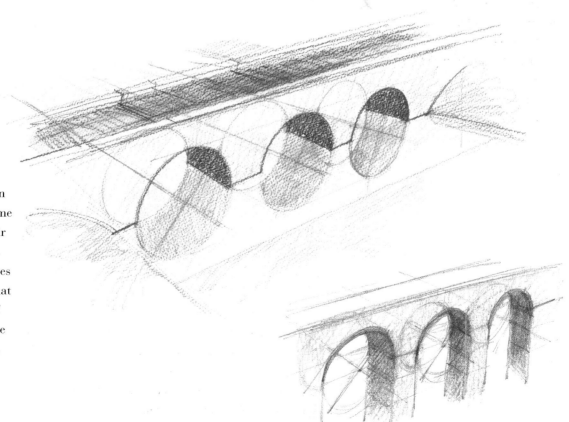

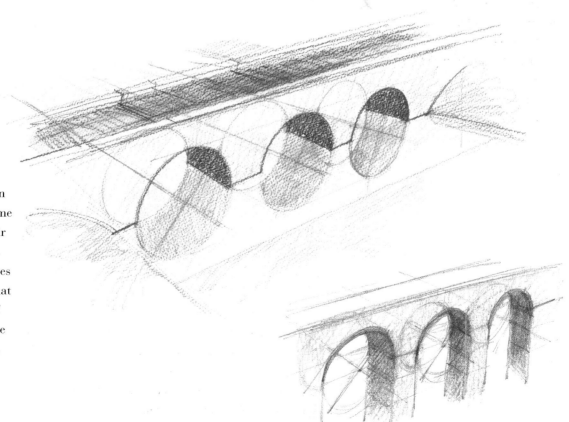

FINDING THE AXIS

By extending the minor axis of the ellipse at one end of a cylinder you find the center line of the cylinder. This functions as the axle for wheels at each end of the notional cylinder.

AXLES

Think of the wheels on this trolley as being ellipses on each end of cylinders; then, remembering the rule of major axis being always at 90° to the minor axis, see that the wheels are not upright ellipses, as you may have thought, but ellipses at right angles to the axles across the trolley.

HALF-ELLIPSES

Semicircular arches (which may be raised on straight pillars) become half-ellipses in perspective. Following the same rule as the trolley wheels, their major axes are at right angles to their axles, which themselves vanish to the horizon. Note that the reflections in still water of semi-elliptic arches of a bridge actually complete the ellipses.

Teapot

Objects such as teapots are hard to explain by rules of perspective. The precise shape of the intersection of a spout with the main body of the vessel is very complicated to calculate, so supplement theory with observation.

SEE ALSO:

• Rounded forms in line, page 22

• Ellipses and cylinders, page 32

• Flowers in vase, page 74

Before starting to draw the teapot, hold it in your hand and look at it from different angles and viewpoints. This will allow you to gain a better understanding of its construction and three-dimensional total form than you will get from a single viewpoint.

Because the emphasis in this exercise is on trying to discover the structure of the object, rather than one view of its outward appearance, you should feel free to move it or move your view of it. Mark the chosen position so that it can be replaced exactly after one of these re-examinations, and check your viewpoint by reference to the surroundings, an edge of a table, for example. Look at the reflection of your drawing in a hand mirror from time to time; any errors of symmetry in the ellipses will be instantly revealed.

Materials

B pencil

Drawing paper

1 Using a rule if needed, establish the vertical and horizontal axes (at 90° to each other). Use these to plot the axis of the teapot, here a line running from the handle to the spout. These are aligned with each other through the center axis.

2 Using thumb and pencil measuring from an extended arm, establish the lip of the teapot spout, and the farthest extremity of the handle.

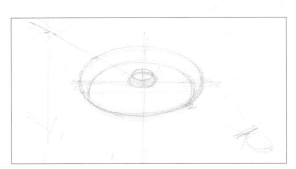

3 Begin drawing the teapot lid and the opening. These are formed by three ellipses—the outer edge of the opening; the edge of the lid sitting within the larger one; and finally, the much smaller ellipse that is the base of the lid's knob. The ellipse of the lid disappears behind the bottom edge of the biggest ellipse.

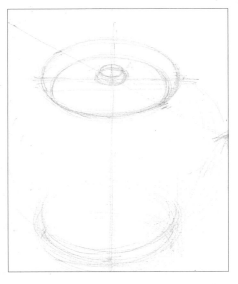

4 Construct the base by drawing the ellipse formed by the base of the teapot. Being lower, this is a fatter ellipse than the higher ones around the lid. Lightly sketch in an imaginary cylinder formed by the lid at the top and the base at bottom. Check the accuracy of its position by measuring a triangle from the spout. Adjust if necessary—do not delete the incorrect ellipse until you have constructed the right one.

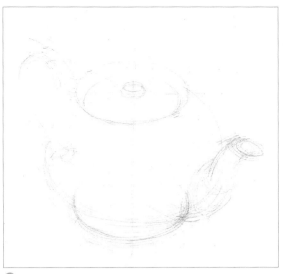

5 Start drawing the form of the spout. Use your judgment to draw in the shape of where the spout joins the body of the pot. The position of the spout's lip may now need refining. Lightly sketch in some contour rings around the body of the spout to help you understand its changing shape.

6 Pick the pot up and turn it round to observe where the handle joins the body of the pot—in this case, slightly lower than where the spout joins the pot's body at the front. Draw an imaginary contour line around the body of the pot, and use this to establish where the handle joins. Observe the shape of the handle and start to draw this in.

7 Thicken the pot's lip by drawing in the ellipse within the already-drawn outer ellipse. Judge the width of this while looking at the subtlety of the shape of a cross section through the neck. Draw in the knob on the lid of the teapot. Reassess its position in relation to the domed shape of the lid, and note how this pushes the base of the knob high up in the ellipse of the lid. Carefully check the position and darken the correct construction drawing, deleting some of the original elliptical guides drawn in establishing the shape.

8 Assess the outer shape of the pot, and judge its widest point here, just below the top intersection of the body and spout. Draw in a horizontal line to confirm this. Continue deleting construction lines as they become superfluous. Construct and define the pot's outer shape.

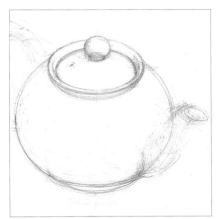

9 Note that the lip of the spout, though similar, is not a true ellipse. Start adding tone to the spout and body to describe their relationship to each other. The changing shape of the spout from its lip to where it joins the body is extremely subtle and demands observation.

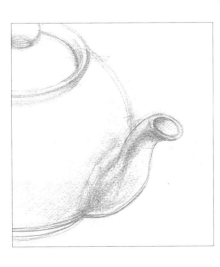

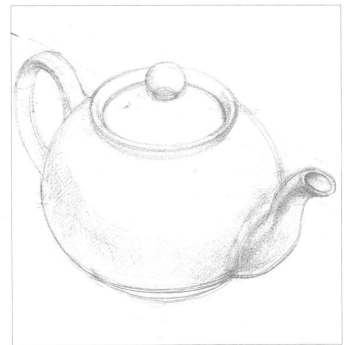

10 Pick up the pot and examine the handle, looking at its shape and scale in relation to the body of the pot. Evaluate the space left between the handle and the body. Draw the outline of the handle's shape and define by adding tone. Delete any remaining construction lines, and finish the drawing by darkening remaining lines and heightening the tonal areas.

Model Boat

Drawing the subtle shape of a boat tends to strike terror in the heart of the beginner. It need not—unbiased observation and applying basic perspective make it quite straightforward.

SEE ALSO:

• Sharp edges in line, page 20

• Vanishing points, page 28

• Boats and jetty, page 100

Pen and waterproof ink were used for this stage drawing. This meant that no lines could be erased, even accidentally, so that you can see precisely how the construction evolved. To discover the form of an object such as this boat's hull, it is again very helpful to draw it as though it was encased in a close-fitting box.

The subtle curves of what is essentially a form symmetrical about its long center, result from their curving through three dimensions in space—up and down, side to side, and fore and aft; no wonder it is difficult to analyze their changes in direction. If you break down these dimensions, first establishing the fore and aft movement by the perspective of the box, then the side to side by plotting the flat plan, and lastly the up and down by pulling this plan shape up at the bow and stern, you will see the typical curves emerge. Having once made a structural drawing like this, you will be find it easier to recognize the shapes you see when you are drawing from life.

Materials

Drawing paper
Steel-nib dip pen
Colored inks
Clean water

1 Using dilute Raw Sienna ink to give pale lines, construct a linear frame to contain the boat, allowing for both its length and its widest part. Use diagonals to determine the halfway perspective points, horizontally and vertically, building a framework within which to work. The "frame" is level with the lowest point of the upper plane of the boat's construction.

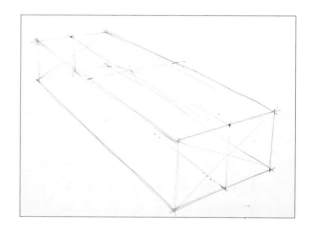

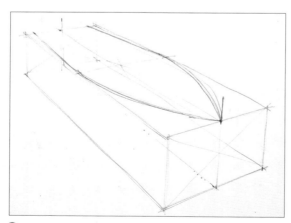

2 Draw in the stern and bow, plotting their height above the frame to give the rake of the boat's construction. Using the vertical halfway line, draw the curves of the boat's sides from the widest point to the bow. Repeat for the rear of the boat, drawing the tapering sides to the corners of the stern.

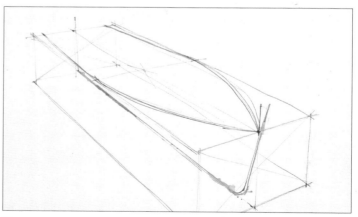

3 Having established its height above the basic frame, draw in the leading edge of the prow. Tilt the line back from top to bottom to allow for the fact that the profile of the prow is not dead vertical. Establish the raised height of the stern, and replot the axis from here to the base of the prow. This is now the keel of the boat, shown here in orange.

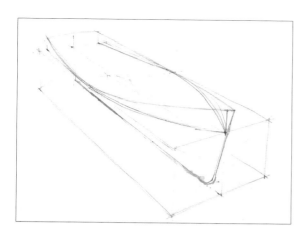

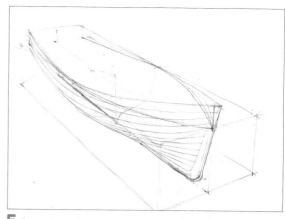

4 Draw the boat's gunwales, taking them from the high point on the corner of the stern down to the lowest point near the center, and up again to the tip of the prow. Owing to the distortion of perspective, the nearest gunwale has a pronounced curve, while the furthest appears almost straight.

5 Draw in an imaginary cross section of the fattest part of the boat, checking this by looking at it head-on (see below). Plotting the planks of the boat's construction gives form to the drawing— they act as contour lines. Note how the widths between them change as they follow the changing shape of the boat.

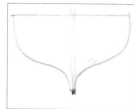

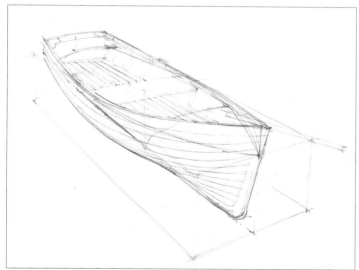

6 Add details to the deck and internal structure of the boat, and thicken the lines of the gunwales.

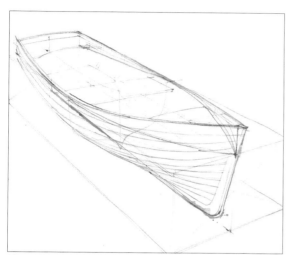

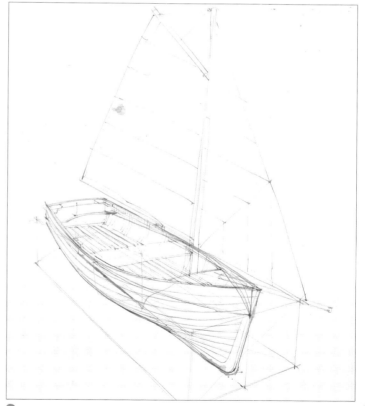

7 Continue to draw the details of the boat, noting that pairs of symmetrical objects, such as the oarlocks, must be carefully plotted to follow the alignment of the frame. When adding the bowsprit, observe that it doesn't follow the immediate perspective of the boat as it is tipped up, with its end resting on the little foredeck.

8 Add the mast and sails, drawing in the main mast first. This rises absolutely vertically from the frame of the boat. The floor, being perfectly horizontal and in line with the keel, follows the perspective lines of the main boat itself.

Lawn Mower

The structure of a machine such as an old lawn mower may appear formidable—but if you look at its overall shape and break it down into separate elements, it responds to the same basic rules as simpler objects.

SEE ALSO:

• Rounded forms in line, page 22

• Ellipses and cylinders, page 32

• Bicycle, page 92

Materials

Light-colored pastel paper
Colored pastel pencils
Fixative

Whenever you are unsure of how the separate components of a machine fit together, look at it from another angle, maybe touching it with your fingers, to help to ascertain the shape and manner of the intersecting parts. Most mechanical objects, however complex, are made up of combinations of spheres, cones, cylinders and regularly shaped boxes.

Tubes and cables that snake about in a seemingly random fashion can usually be added when the basic structure is complete. When you come across more subtle volumes, you must work in the same way—by fitting an appropriately shaped and proportioned box, sphere or cylinder around it and, like a sculptor, carving away pieces you don't need.

1 An apparently complex piece of machinery such as this becomes much simpler when analyzed as a series of cylinders. Following the basic rules here most machinery can be tackled, as it tends to be comprised of similar elements.

2 Plot the two wheels by lightly sketching an imaginary cylinder containing them. Remember how in perspective the nearest of the two ends of the cylinder is a shallower ellipse than the farther one. Add details to the wheels, noting the intricate relationships of their elliptical structures, and lightly draw the minor and major axes of the two end ellipses.

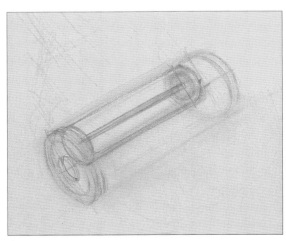

3 The drawing construction of the blades is based on an imagined cylinder containing the round plates that hold the blades, and an outer cylinder that contains the outer shape of the blades. Draw in the axis of this part of the construction. Constantly check the accuracy of the drawing—mistakes can easily be deleted and rectified when using pastels.

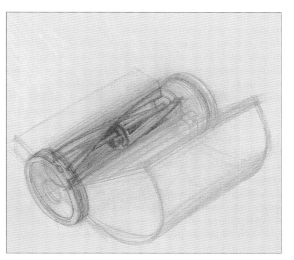

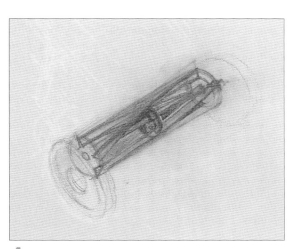

4 Define the blades as they curve over the surface of the cylinder. Drawing these will be helped by direct observation but also through an understanding of their shape and construction based on examination.

5 Using a darker pastel, define the shape of the wheels. Begin adding to the overall drawing by describing the grass box, looking at it both internally and externally to help understand its shape. This cuts into the imagined cylinder of the wheels, but being parallel with this, it follows the same perspective lines.

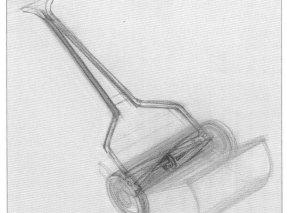

6 Working over the original plotting lines, define the handle, checking with a mirror for accuracy. Look at the symmetry of one side against the other, drawing across in faint perspective lines to help this process.

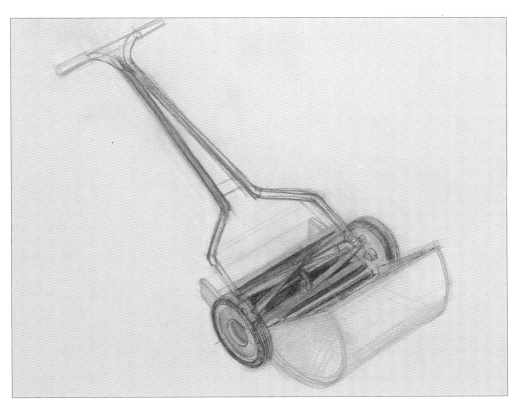

7 Add the final details, once again using dark pastels. Reinforce the visible parts of the machine in the drawing to distinguish them from the "construction" drawing. Add a little tone to give form. Use fixative to protect.

Leading the Eye

SEE ALSO:

• View through a window, page 96

• Interior sitting room, page 124

• Sketchbook, page 148

It may be true that composition is not so vital in a sketchbook as when making drawings for a painting, but a simple sketch will have more impact if its positioning on the page is effective.

The eye tends initially to be attracted to the center of a drawing or painting, so a centralized composition is almost guaranteed to work well. Such symmetry also makes for a very still and calm picture, and there is little need for directing attention to the main subject.

However, compositions need not rely on symmetry to achieve an appearance of balance and calm; you can achieve stability by placing the main subject offset from the center, but just at the right spot where it is balanced by the other masses. Where is the right spot? Well, mostly we find it by trial and error, but there is a centuries-old system that uses mathematics to divide rectangular spaces in harmonious ways so that subjects placed on these divisions are found to be satisfying and somehow "right." The system is referred to as the Golden Section, or the Rule of Thirds, which describes it accurately.

There are one or two generally accepted compositional "don'ts," and so long as these are avoided, the chances of attaining a satisfactory composition are increased. Placing main and secondary subjects at or near the picture edges, for example, is generally to be avoided. Try not to have the outer edge of any object, especially a figure, coinciding precisely with the horizon or any other strong linear division of the drawing.

Composition is an abstract quality, so I suggest that you experiment by playing with lines and shapes within rectangular frames. It is important not to be too controlled when experimenting like this—let things happen as they will, and watch for happy accidents.

SYMMETRY

This is often decried as boring in a composition, but it can work well and should not be dismissed so lightly. The eye tends initially to be attracted to the center of a drawing or painting, so a centralized composition is almost guaranteed to be balanced. Such symmetry also makes for a very still and calm picture, and there is little need for directing attention to the main subject.

HORIZONTAL
Dividing the composition by a straight, horizontal line is inherently still and suggestive of calm, perhaps because of its connotations of a distant horizon on an empty landscape.

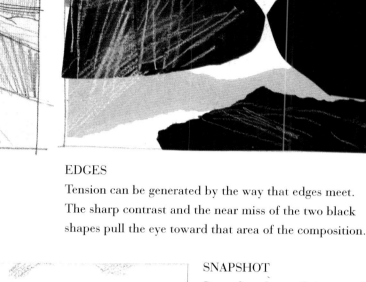

CONVERGENCE

When the main subject is not at the center, one method of directing attention to it is by the use of lines converging on it from other areas of the drawing.

EDGES

Tension can be generated by the way that edges meet. The sharp contrast and the near miss of the two black shapes pull the eye toward that area of the composition.

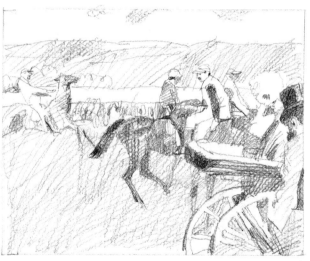

SNAPSHOT

Since the advent of photography, the semi-accidental snapshot has suggested how a sense of immediacy and drama can be achieved by placing a foreground feature, perhaps even a figure, not only near the edge of a picture, but even partially cut off by it. In this simplification of a painting by Edgar Degas the carriage is nearly out of the picture and there is a large empty space on the left.

COMPLEX BACKGROUNDS

Another way to direct the eye is to surround the main subject with complexity in contrast to bland, open areas elsewhere. (Simplification of a portrait by Gustave Klimt.)

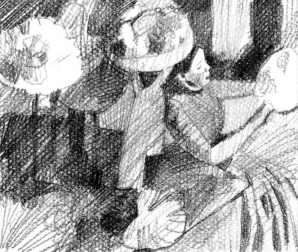

CONFLICT

Another "rule" says that you should not place human figures so that by the direction of their gaze they deflect attention out of the picture area. By adding other strongly directional features that drag the eye back into the picture, this too can be overcome, and the little element of conflict makes the composition more interesting, as in this sketch of a painting by Edgar Degas.

Using Color

To understand the role of color in composition, you will need to be familiar with concepts such as color temperature, color harmony and dissonance, and the interaction of complementary colors.

SEE ALSO:

• Rounded objects with tone,
 page 26

• Contre-jour,
 page 52

• Sketchbook,
 page 148

Colors close to each other in the color circle will harmonize together, the closer together, the more secure the harmony. Colors directly opposite each other are known as complementary colors. When placed together they interact, sometimes creating extreme discord or dazzle in the observer's eye.

If a composition is largely made up from harmonizing colors in, say, the blue-green range, a small spot of orange or red will contrast violently with them and attract attention, holding up its side of the compositional balance against the other larger, calmer areas.

The converse also works well, with large areas of harmonic oranges and yellows, balanced by smaller areas of contrasting complementary blue-mauves.

You will find that colors have different power in a composition depending on their surroundings—colors that are encased in black, for instance, almost always gain in intensity and luminescence.

Incidentally, mixing actual pigments together where the colors are near neighbors on the color circle, will produce clear new variations, while mixing complementary pigments will result in dirty gray colors.

THE COLOR WHEEL

This informal representation of the color wheel stresses the fact that color is often linear or broken. The complete triangle points to the three primary colors of red, blue and yellow. The other three points indicate the secondary colors of orange, green and violet. The segment of the color circle that is considered "warm" begins at yellow and extends through orange to the most scarlet red. Although the color red is almost, by definition ,"hot," it goes through a stage where it loses all its yellow content and edges toward mauve, where it becomes almost cool. This point can be recognized by mixing white and red pigments. If this produces a pink that does not edge towards a salmony tint, however much white is added, that is the first of the cool range. This continues through the purples, mauves, blues and greens to include the slightly green yellow generally known as lemon yellow.

TINTS AND SHADES
The lines on the right show the color changes created by adding white or black to a particular color.

SUBTLE SHADES

It is unlikely that you will use pure spectral hues when drawing—you are much more likely to be using complicated colors involving varying amounts of black. The same principles apply, however—a composition largely dominated by blue-blacks, gray-greens and so on will be much enlivened by a little orange from the other side of the color circle.

A WARM SCHEME

A predominantly warm brown/orange composition may benefit from the addition of a small area of complementary green/blue. I am not suggesting that you should be limited by these suggestions—there is absolutely no reason why you should not compose with a riot of color or no color at all. But in the absence of a better idea, this principle usually works reasonably well. You may find it helpful, when making experimental compositions like this, to suggest vaguely some subjective content, as here, but it is not essential if you prefer to work with purely abstract shapes.

COMPLEMENTARY COLORS

Playing around with full-strength primary and secondary colors demonstrates how they can interact. For the fullest dazzle reaction the tone as well as the hue must be absolutely right, and variability in printing may not show exactly what was put down in these examples.

Strong, Direct Light

Strong, single-source light, falling on an object produces sharply defined, contrasting areas of light and shade. Drawing this type of light requires bold treatment and positive decisions.

SEE ALSO:

• Rounded objects with tone,
 page 26

• Ellipses and cylinders,
 page 32

• Fruit and vegetables,
 page 82

Because strong direct light is concentrated either as a point source or as the parallel rays of the sun (which is so far away that it can be treated as a point source), one side of the subject is bathed in light, while the far side receives almost none at all. It is assumed for this exercise that the light fall is from one side or the other, rather than from behind the subject or directly in front of it, both of which are special cases. As in drawing with tone (see pages 26–27), first find the line of main change between light and shade, then look at the color of the lit and shaded areas. A common error is to assume that an object's light side should be depicted with its intrinsic color plus white, and its shadowed side with the same color plus black.

In fact, the side bathed in light will be the brightest version of the intrinsic color of the subject, not that color mixed with white, and the shadowed side will almost always be receiving some light reflected from its surroundings, and may be an entirely different color.

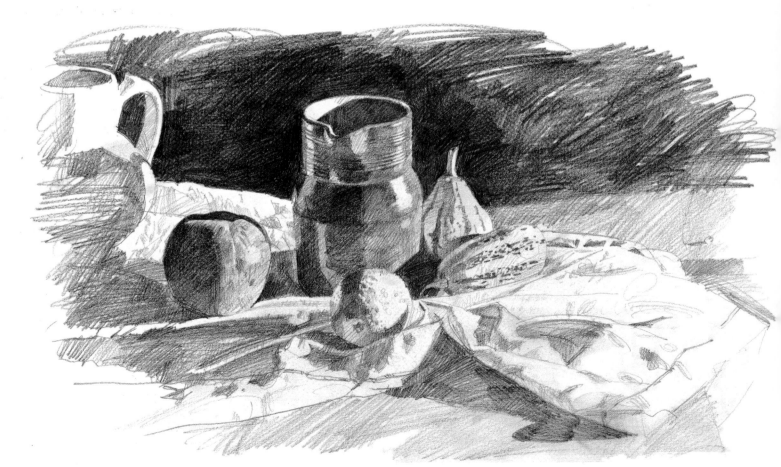

SUNLIGHT INDOORS
Light objects have strong contrasts, and dark objects gleam with reflection in this stongly-lit still life.

Materials

Pastels

Mid-tone pastel paper

Fixative

Choosing your background

Using a mid-tone paper enables you to work in two directions, one toward the lights, and the other toward the darks. The apple is placed on a pale gray-green paper because a white ground would be too harsh.

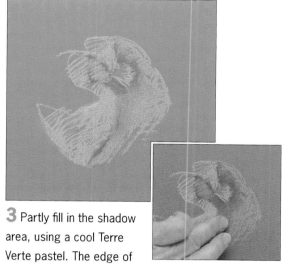

1 Using a darkish Olive-Green pastel, draw in the edge where the directional light, hitting the nearest side of the apple, fails to illuminate it. The curved shape turns away from the light source, leaving a band of dark shadow.

2 With a Hooker's Green pastel draw in the first of the tones of the lit area, butting up against the darker area drawn in stage 1.

3 Partly fill in the shadow area, using a cool Terre Verte pastel. The edge of the apple begins to emerge. Allow a little of the paper to show through and blend visually with the colors.

Inset: Blend in the Terre Verte with the Olive-Green by gently rubbing with a fingertip.

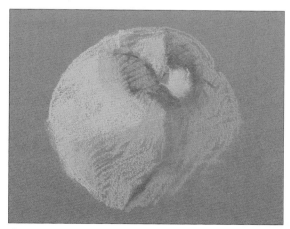

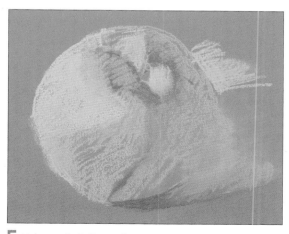

4 Using a warmer, brighter, Grass Green, fill in the illuminated area (with the exception of the highlight), taking it to the apple's edge as in the previous step.

5 Using a dark Green-Gray pastel, begin the dark area of cast shadow where it is at its maximum contrast to the lighter tone of the apple, sharply defining the apple's edge. Indicate the warm reflected light in the apple's base by letting the color of the paper show through.

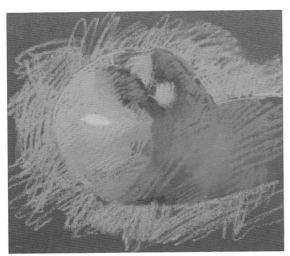

6 Using a light Lemon Yellow pastel, add the strong highlight—don't use white because this looks too hard and artificial. Continue to extend the background area around the apple.

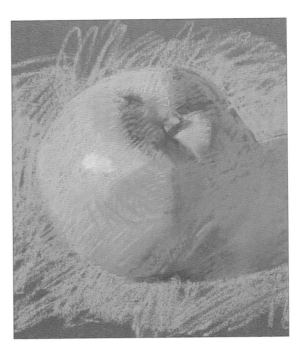

7 Indicate the stalk by drawing in its cast shadow with the dark Olive-Green pastel. Add a little extra warmth and brightness to the lit area by crosshatching a darker Lemon Yellow and some Grass Green into it. Strengthen the highlight if necessary.

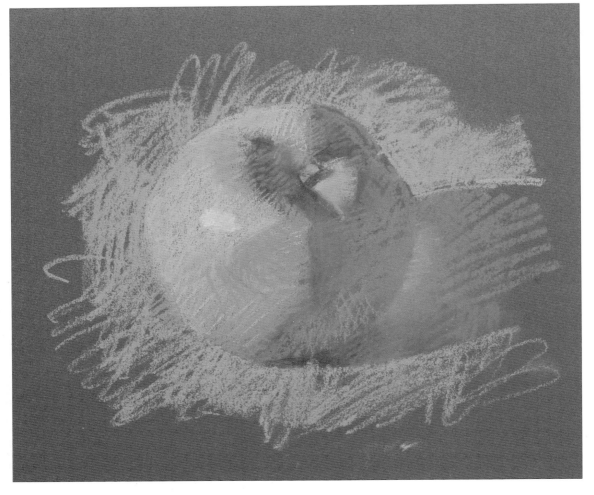

8 Carefully modify the background where it is the same tone as the apple by adding a small amount of Olive-Green. Reduce the intensity of the warm reflected area at the base of the apple by delicately hatching in a little Hooker's Green. Use fixative to protect.

Soft Light

Soft light with gradual changes from light into shade, with no sharp divisions between the two, is typical of the famous north light that has been preferred by artists over centuries.

SEE ALSO:

• Rounded forms in line, page 22

• Using color, page 42

• Fruit and vegetables, page 82

This characteristic of north light is a result of the sunlight being reflected from the sky, with no direct sunlight reaching the subject. Apart from its gentle character, indirect sky light has the additional advantage of being more or less constant all day long, giving you time to explore it without rushing. (In the southern hemisphere the converse is the case, of course, because the sun moves through the northern sky, thus making south light the desirable one for constant soft light.)

To draw this type of light you need to bring out much more subtle changes of color and tone across the subject, with less reliance on the shape of a strong demarcation between light and shade. Edges can be softer, too, suggesting the presence of air between the artist and the subject. There may still be reflected light in the shadows, but this is likely to be less obvious, which is as you would expect, there being less strident light falling on the surroundings to be reflected onto the main subject. Expect highlights to be discernible—but again, unless the subject is very shiny and reflective, these are likely to be softer in outline.

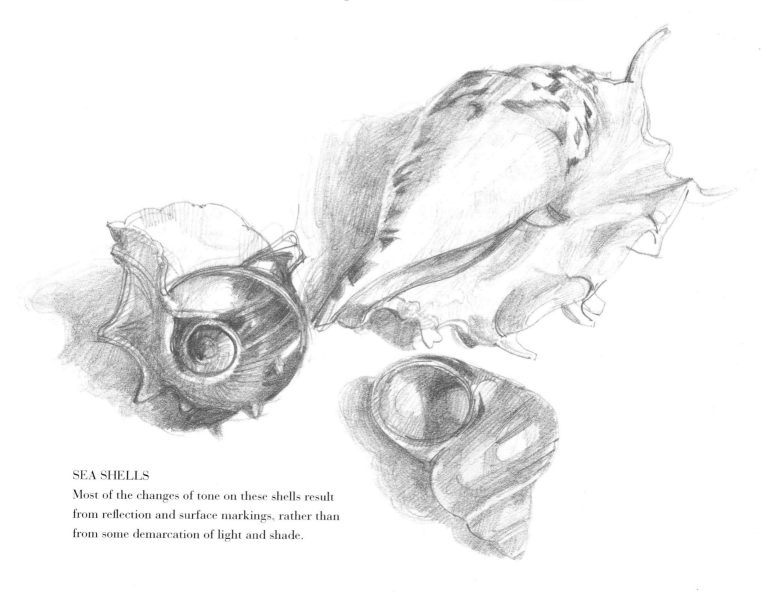

SEA SHELLS

Most of the changes of tone on these shells result from reflection and surface markings, rather than from some demarcation of light and shade.

Materials

Pastels

Light-colored pastel
 paper

Fixative

1 Using a Grass Green pastel, loosely lay down a body of color approximately equivalent to the apple's shape. Repeat, using a deep yellow for the bell pepper. Because the final image will be generally flat, with no extreme contrasts of tone, lay the body color down with a dense evenness.

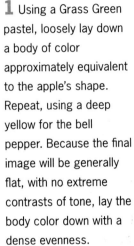

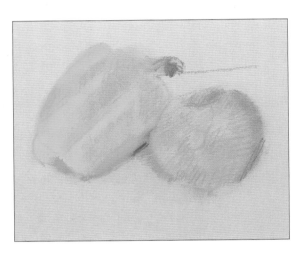

2 Using Terre Verte, add a little tone to the far right side of the apple. Because the light coming from the left is extremely diffused, there is no hard demarcation line between the illuminated edge and the shadow. Using Grass- and Sap Green, add color detail to the apple. Draw in a little of the shadow area between the apple and bell pepper with mid-tone Cool-Gray. Note that in soft light subjects are gently defined with soft, fuzzy edges.

3 With a light Raw Sienna pastel, start detailing the color changes within the bell pepper's shape. Work a little Grass Green into the cooler areas, and blend this into the yellow base of the drawing. Extend the soft shadow areas around both the apple and bell pepper, and broaden it, using a very pale, Cool-Gray pastel. Start drawing the bell pepper's stalk with the dark Terre Verte pastel.

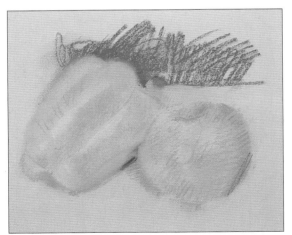

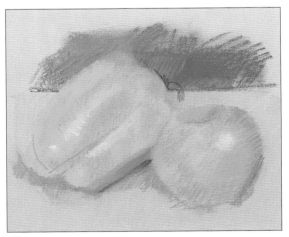

4 Add the subtle highlights to the bell pepper using a very pale Yellow Ocher. This will help you to evaluate the other tones in their relationship to the highlight. With a mid-toned, Cool Brown pastel define the edge of the bell pepper and the horizontal line where the flat base on which the subjects are placed meets the vertical background. Add a little warm detail to the apple with the Raw Sienna.

5 Soften the brown background with the mid-tone Cool-Gray pastel. Throughout the drawing, make sure that the color and tone changes, although subtle, are never weak. Examine the shapes within the drawing, such as the bell pepper, and refine them if necessary. Add a soft highlight to the apple, using a pale Lemon Yellow.

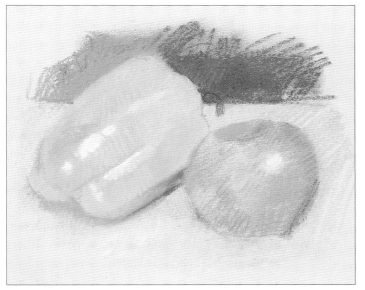

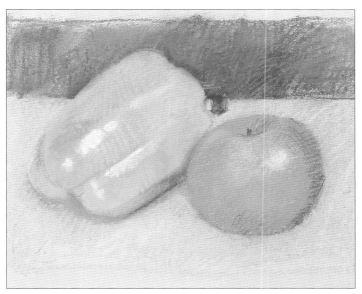

6 Fix the drawing before continuing to work into it. Use a Deep Yellow pastel to refine the edge of the bell pepper where it meets the brown background. Using the paler green pastels, add more color to the bell pepper, taking care not to damage its subtle form.

7 Mix the cool Mid-Gray and the Brown together to mute down the background hue and accentuate the edge of the bell pepper without letting it become over-sharp. Work into the apple, giving form without strong demarcations. Using the Brown pastel, add an area of soft, warm shadow thrown by the apple on to the bell pepper, again keeping the edges gently gradated.

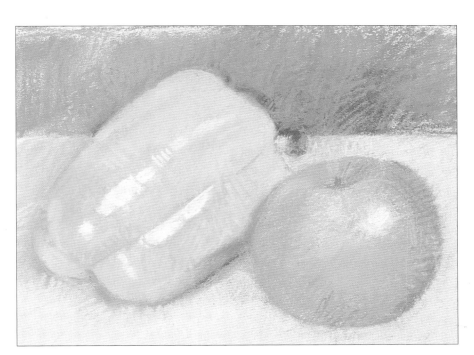

8 Introduce a little Cadmium Orange to give the bell pepper an intensity of color around the highlight areas. Because the bell pepper has a high gloss surface, these highlights have a finely defined edge, even with soft lighting. Use fixative to protect.

Dappled Light

Light filtering through the leaves of trees, or other incompletely shading barriers, makes attractive and evocative patterns. Dappled light may look complicated to capture, but not so much as you might think.

SEE ALSO:

• Sharp edges with tone, page 24

• Vanishing points, page 28

• Using color, page 42

There are many different ways in which the illumination of your subject can be partially interrupted, allowing characteristic bars or pools or speckles of light to be interspersed with similar areas of shadow. The pattern made by sunlight filtered through leaves is very evocative of summer days. Dappled light cast on the subject or the ground tends to be rather unfocused, like soft-edged, more or less circular, pools. These will appear distorted by the form upon which they fall. On the ground they may appear as soft ellipses or clusters of ellipses, and on vertical surfaces they may be stretched to stripes.

Bars of light and shade, such as those produced by venetian blinds, are not only distorted as they fall on a solid object, but their regular undulating stripes can be used to dramatize and accentuate the form.

It may seem destructive to the form of your subject to break up a shadow area with splashes and bars of light, but draw what you see boldly and with conviction—you will be surprised at how well it turns out.

Materials

Conté pencils

Clean water

No. 6 sable watercolor brush

Cold-press watercolor paper

1 Using a Raw Sienna pencil, sketch in the composition of the overall structure, largely ignoring the shadows, apart from giving a broad indication of the direction of light and shadow.

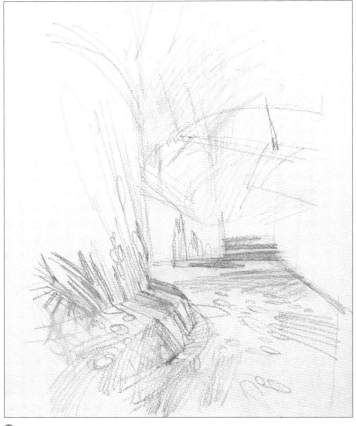

2 Start to draw the shadows with Raw Umber, allowing them to define the forms. The pools of light are mostly circles seen in perspective as ellipses. Where the leaves of the tree are close to the wall, the shadows and light between are in focus and show the leaves' patterns. This brown drawing is modified with Cobalt Blue, Lemon Yellow and Blue-Green. Add some sky with pale blue pencil.

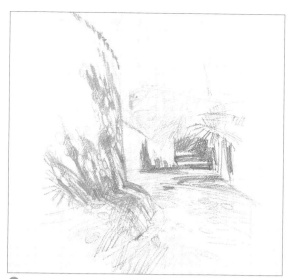

4 Draw the darkest leaves with a dark green, and strengthen them with an even darker brown. Blend the colors together using a brush and clear water, eliminating the overall linear quality of the drawing. Draw back into the moist areas for a darker, softer line. Add hot spots using Orange.

3 Begin to draw the light areas with Naples Yellow. Define the shadows on the wall using Mid-Blue and Raw Umber—mix the colors to show the warmth of the wall and the cool of the shadow. In addition to the projected shadows of the trees, there are also the cast shadows of the feature high on the wall.

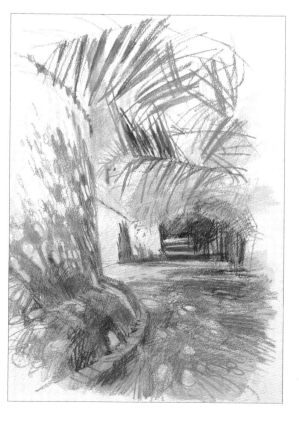

5 Strengthen the sky using a mix of blue pencils, then soften them by rubbing with a finger. Work freely over all the shadow areas with the range of colors to deepen the tones, heightening the pools of light—those on the tower wall get thinner as they turn towards its edge, away from the viewer.

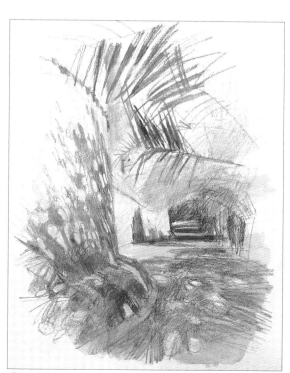

6 Using the brush and clear water, work back into the shadow areas, enriching and softening them.

7 Darken the shadows further to reinforce the contrast with the pools of light. Give extra definition and detail to the palm leaves.

Contre-Jour

SEE ALSO:

- Using color,
 page 42

- Strong, direct light,
 page 44

- Portrait head,
 page 140

The most extreme example of an against-the-light situation, known universally as contre-jour *(French for "against the day"), is a silhouette.*

Although subjects that are lit from behind do not constitute a change of light quality, the way the light falls is markedly different from subjects lit from any other direction, so it deserves special consideration. In this mode, the subject appears completely dark, maybe black, in contrast to the bright background. Photographs, unless filter compensation is made, often show objects with the sun behind them as black, but the eye can usually distinguish some color *in situ*, even in extreme situations. In less extreme cases a rim of light may be visible around the subject and by shifting your focus, you may be able to distinguish reflected light in the shadow area.

When your subject is closer to you and also closer to other objects that are in more direct light, the silhouette may be alleviated (or illuminated) even more by color reflected from the surroundings. As always, if you think that you can see a color in the shadow, believe what you see—no one can say that you're wrong. It is better to make a decision and take a small risk with a positive color than to play safe with indecisive grays.

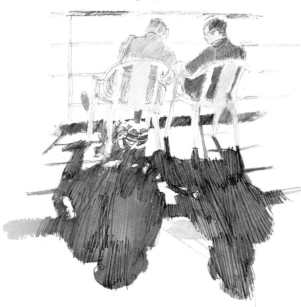

CAST SHADOWS
Often the cast shadows from a contre-jour subject are darker than the subject itself.

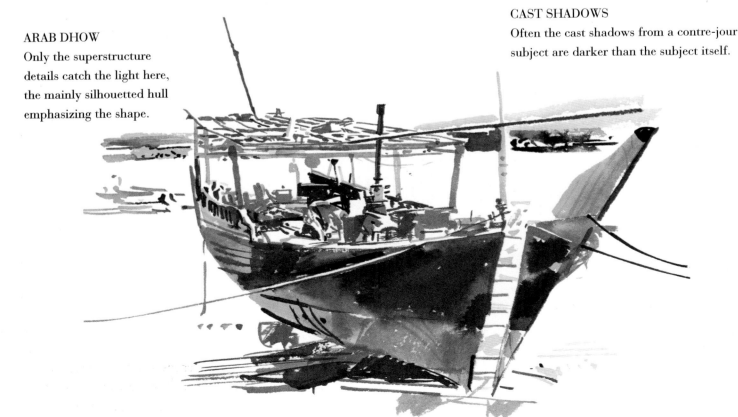

ARAB DHOW
Only the superstructure details catch the light here, the mainly silhouetted hull emphasizing the shape.

Materials

B pencil

Heavy drawing paper

1 Plot the overall shape of the face and shoulders. Shade in a little of the tonal areas, noticing that the background is the darkest. This establishes the basic shape of the drawing and its initial tonal areas. Allow the direction of shading to flow in whatever direction seems natural—don't slavishly follow one direction only.

2 Begin defining the features, especially the eyes, which will be the strongest element of the face in this sort of light. Don't allow any of the drawing to become too dark. Reflected light often comes from below, rather like theatrical lighting. Use a piece of scrap paper to protect the drawing from being rubbed once you have established the tones.

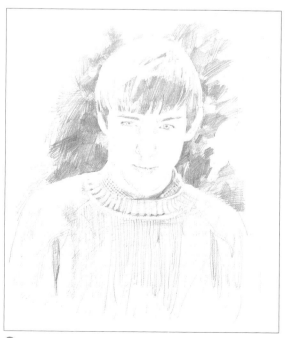

3 Finalize the edge of the hair, leaving the paper white where the head is picking up rim lighting. Gradually build up the darkest areas—putting a hard surface beneath the paper helps. By resolving the surrounding tones you can evaluate the soft tones on the face.

Inset: Keep the pencil sharp to make strong, dark tones.

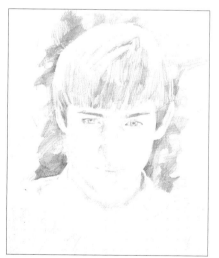

4 Work on the features—the face is very pale because it is illuminated by reflected light, but it has a very soft tone distinguishing it from the brightest tone of the rim-light.

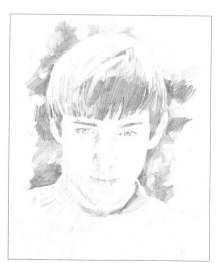

5 Work around the edge of the hair noting how the tiny hairs pick up light.

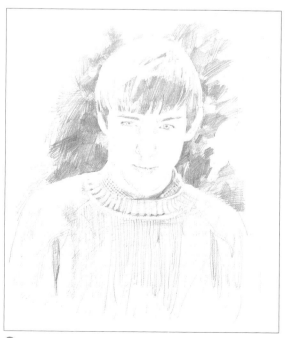

6 Finish by working on the details of clothing. Watch the tonal values carefully, and check how much the shoulder areas pick up the bright, direct light.

Wood

The texture of wood is essentially a matter of striations, of linear patterns derived from the annual growth rings of the tree.

SEE ALSO:

• Sharp edges in line, page 20

• Rounded objects with tone, page 26

• Ellipses and cylinders, page 32

Materials:

Thin to medium charcoal sticks
Soft putty eraser
Drawing paper
Fixative

If wood is untouched by human hand—detached from the mother tree by natural forces of wind or lightning strike, for example—you may find striking linear patterns on its surface, and even more if it has been worked upon by forces of erosion. Driftwood is probably the most extreme form of this type of modification by erosion, often assuming the most extraordinary and fantastically distorted shapes.

After perhaps weeks of immersion and battering by waves, the softer wood between the rings may have been washed away, leaving the grain raised and exaggerated in form. Twigs and lesser branches will have been torn away, leaving stark, stripped versions of the original tree branch. Bring out these linear shapes, emphasizing their twists and turns with similar vigorous strokes. Of course, the sea also throws up wood in the form of cut planks of timber from which all the natural growth forms have been eradicated —these may be less interesting, though they may still show some surface patterning.

Once wood has been shaped by saw, ax and plane, it assumes a different set of textures—characteristic grain patterns become more visible as the surface is polished, and you then have to decide whether these patterns are more important than the reflectivity of its smooth shininess. Woodcarvers and turners have found further ways to modify and emphasize wood grain patterns, and in these spherical and cylindrical worked forms you should try to combine both the surface patterns and the smooth, man-made form.

1 Because charcoal can be endlessly corrected, don't be reticent; establish the overall structure with bold, fast strokes using a medium charcoal stick.

2 Rub with a finger to diffuse the marks and give softer tones.

3 Using a fine stick of charcoal, begin to establish some first details. Look for rhythms of patterns in the wood's surface and texture.

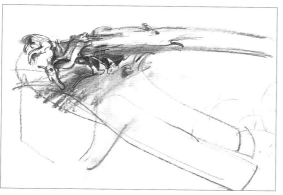

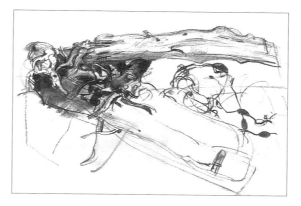

5 Exploit the variety of marks that can be made with charcoal by using different pressures on the stick—faint lines by gently stroking; intense blacks by firm drawing; fine details by snapping the stick to create a sharp point.

4 Continue to draw details, building up the form of the wood. Use the ability of the fine stick to render rich blacks, to depict the dark discoloration on the wood's surface, and accentuate the form.

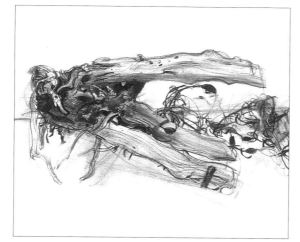

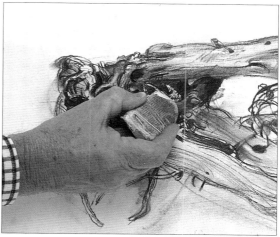

6 Using a sharp-ended stick, draw in the seaweed sticking to the roots, contrasting its dark fine shapes with the worn, smooth quality of the wood. Erase any marks or areas that are no longer required.

7 Draw back into the image, softening the tones by rubbing with a finger. Use a freshly cut edge of a soft putty eraser to draw "whites" into the black and gray tonal areas. Fix before proceeding.

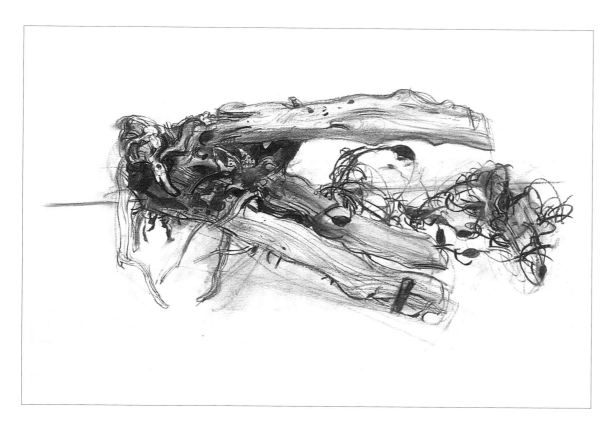

8 Draw in the horizon line to establish the image in space. Work over the whole drawing, finalizing details and intensifying the darkest areas. Use fixative to protect again when finished.

Stones and Rocks

Rocks and stones have wonderfully rich and varied textures. These develop during the rocks' original formation, the erosive action of wind and water, and the action of any microbial or plant covering.

SEE ALSO:

• Vanishing points, page 28

• Strong, direct light, page 44

• Boats and jetty, page 100

Developing an understanding of the basic principles of rock formation will help you to appreciate the textures involved.

There are three main kinds of rock—igneous, sedimentary and metamorphic.

Igneous rocks were once molten and, depending on how quickly they cooled, may have smooth, shiny surfaces, or be porous and dull, such as pumice. If the rock cooled extremely slowly it accumulated mineral crystals, giving a mottled appearance (as in the granite pebble, bottom right).

The second type were laid down as sediment, mostly on ocean floors. They have a layered appearance, and the colors depend on the muds or marine creatures that composed the layer, each of which can be richly varied. The layers are often bent and twisted into shapes (middle right).

The third group covers rocks that include both the previous ones, but that have then been transformed by pressure, heat or chemical action.

The methods that you use to draw these various textures are less important than the recognition of the typical features, but try rendering the more random colorations with finger dabbing, monoprinting and toothbrush spattering. A sharp pencil was ideal for capturing the glass-like crystals in the piece of quartz (top). The layers in the stratified rock in the middle were emphasized with pen and ink, and color was applied by dabbing with a finger.

A good tip when drawing rocks is that wetting or spraying them with pastel fixative or varnish will bring out their beautiful colors.

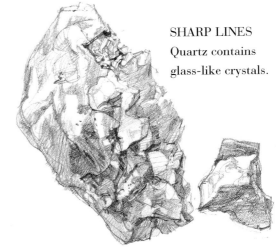

SHARP LINES
Quartz contains glass-like crystals.

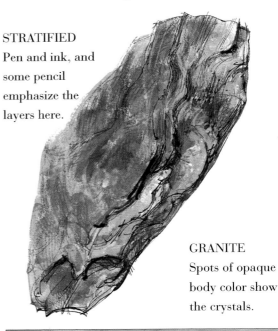

STRATIFIED
Pen and ink, and some pencil emphasize the layers here.

GRANITE
Spots of opaque body color show the crystals.

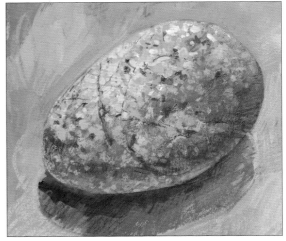

Materials

Light-toned pastel paper
HB pencil
Colored pencils

1 Lightly map out the patterns of the rocks against the background of the hill. Look for the structure, and don't be tempted to make up the shapes.

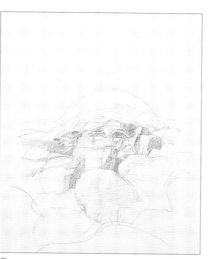

2 With the basic forms established, start to add more positive marks. Block in the main shadow areas, and darken the tones of the distant rocks.

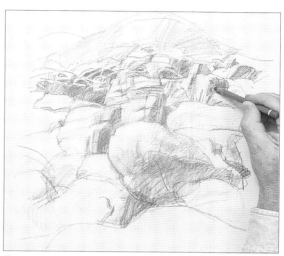

3 With the paper still acting as the lightest tone, add light Gray-Blue to suggest more fissures and shadows; the darker tones make negative shapes against the highlights. Shade the hill to suggest its contours.

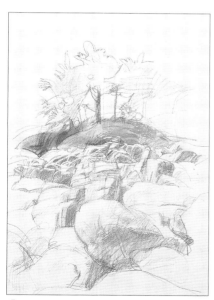

4 Block in the trees, and add the main color to the hill.

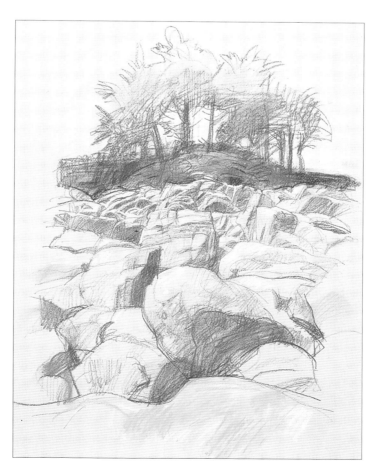

5 Add a touch of light blue sky to throw the scene into relief, then emphasize the tree and hill shadows. As you establish the pattern of light and dark on the farthest rocks, strengthen the foreground with bold strokes. Much of the texture here results from the combination of relatively smooth forms, their complexity increasing with distance.

Metal

Metal is man-made, and there is almost no limit to the forms it can take. Textures vary from the roughness of sand-cast forms to highly polished and mirror-like surfaces.

SEE ALSO:

• Ellipses and cylinders,
 page 32

• Teapot,
 page 34

• Glass bottles,
 page 88

Objects made by working sheet metal, or highly polished solid items, are probably the most interesting to draw. Form can be deduced from the way that the reflections in the smooth, undulating surfaces are compressed and extended.

The higher the polish and reflectivity of the metal, the less its form will be revealed by light and shade. A polished silver teapot, for example, acts like a distorting mirror—if you really look into the shapes that are there in its surface you will see recognizable, although changed, versions of its surroundings. It is difficult to predict exactly how the reflections may be distorted, but as a general rule, they will be increasingly compressed as a form turns away from your view, and more expanded in the planes facing to the front.

Given the unpredictability of these strange and often sharp-edged shapes, it is astonishing that we are able to deduce, usually without difficulty, the three-dimensional shape of objects with such bewildering reflections. So long as you have the courage to draw these reflections as hard-edged and sharp as you see them, the viewer will similarly interpret them and read the form.

BOAT ANCHOR
The mottled surface patina was imitated by spattering white gouache over gray and black.

Materials

Steel-nib dip pen
India ink
No. 6 sable watercolor
 brush
White Ingres paper
Clean water

1 Position the faucet (tap) so that it presents an unfamiliar aspect. This ensures that you will not be tempted to draw what you think you know, and makes it necessary to look at the object anew. Because it is difficult to modify mistakes, start the drawing carefully by plotting the outline of the image with pale dots, using dilute India ink.

2 Define the edges of the major reflections. Because these are hard-edged, this can be done in line. It is impossible to tell where the major light source is on such a highly reflective surface, so use the distortion of the reflections to gradually reveal the form of the object.

3 While remaining alert to the overall proportions, continue to bring out the sharp-edged shapes in the reflections. If you look closely, you may see your own hand or arm reflected in the surface.

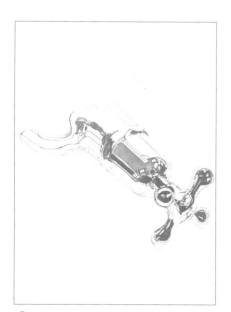

4 Fill in the dark shapes on the barrel and handle of the faucet with a brush and ink. Some of these shapes are dense black, others are lighter gray.

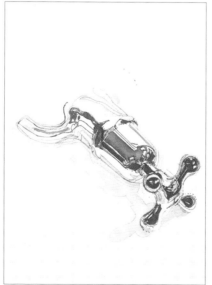

5 Some of the shapes are colored, depending on the color of the surroundings that are being reflected. Indicate the shadow of the faucet to define the light edges.

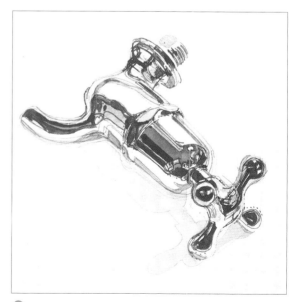

6 Continue to follow the sinuous shapes in the spout and its connection with the main barrel. The intrinsic color, the "silvery" quality of the chromium, only emerges as a result of reflecting its surroundings.

Glass

What an incredible substance is glass: transparent, reflective, refractive, multicolored, malleable when hot, and never completely solid—even window panes flow, albeit exceedingly slowly.

SEE ALSO:

• Vases and flowers, page 16

• Ellipses and cylinders, page 32

• Glass bottles, page 88

As with polished metal, what you draw when you are depicting colorless glass is not actually the substance of the material itself, but the reflection in it of the surroundings. Added to this, you can also see through the glass to yet other forms. So when you make a drawing of a glass object, you are really drawing how it represents and distorts other objects. Because the surface of glass is very smooth, the reflections in it are sharp-edged, just as they are in polished metal. Resist the temptation to suggest its surface with soft blurs, as are sometimes used in advertising drawings to depict the surface of a mirror— there is no blurring in a good mirror, all is brittle and crystal clear. Of course, in common with all shiny subjects, some light will be reflected back to the eye in the form of highlights, and those in clear glass subjects are likely to be very bright, needing pure white to depict them.

If the glass is colored, all the reflections will be just as sharp, but seen through a transparent glaze of color that may also tint the highlights a little.

To sum up, the trick—if there is one—for drawing glass, is to look under the surface that you sense, and discover the sharp shapes that together make that invisible surface apparent.

CUT GLASS
The cuts in the surface of this decanter not only break up the reflections to form an intricate pattern, but also follow and reveal the form.

Materials

B pencil

Rough watercolor paper

Soft putty eraser

Nos 3, 5 and 7 sable
 watercolor brushes

Watercolor paints

Clean water

Hair dryer to speed
 drying (optional)

1 Draw in the basic elements of the still life lightly, describing their overall shapes and outlines and establishing their relationship to each other.

2 Draw the shapes of the strongest reflections. Note how the same light source, in this case a skylight, recurs in the undulating shape of the right-hand bottle. Add the details of the shapes and patterns on the surfaces, describing them in pure line.

4 Before applying a wash, rub gently all over with a putty eraser to reduce the heavier pencil lines and degrease the paper's surface. Apply the flat wash on the coffee pot using very liquid red paint on a fully loaded No. 7 sable brush. Work from the top, making a pool of water with a flooded edge along the bottom. Keep adding to this loaded edge until the pencil edge of the base of the coffee pot is reached.

3 Look into the glass to observe the sharp-edged shapes of light and color; softer in the clear carafe, harder in the right-hand blue vase. Observe how shapes of other items, such as the coffee pot, are distorted when seen through the glass items.

5 Starting from the top again, add a preliminary blue-green wash to the right-hand vase. Be careful to work around the bright highlights, leaving the paper to read as bright white. The blue wash should correspond in tone to the brightest of the blues seen on the vase. Complete the color wash of the coffee pot, glazing over the top half and modifying the original wash as you do so. Add a little darker blue to the vase seen through the carafe.

6 Using a more purple blue, add a secondary glaze to the blue vase, leaving the lighter blue as highlights only. Mix a neutral gray with a hint of green for the preliminary wash on the carafe, and some red areas of the coffee pot seen through the carafe.

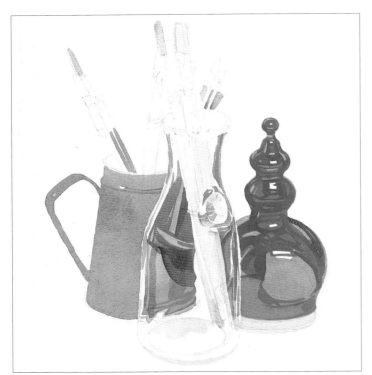

7 Using the No. 3 sable brush and a more purple neutral tint, add the details of the embossed seal on the carafe, noting how it distorts the brushes seen through it. Using an even darker blue, add a third wash to the blue vase, now leaving both the mid and light blues as highlights as well as the original "whites" of the untouched paper. Using a Raw Sienna wash, paint in the cork at the base of the vase, and extend it over the blue area where the cork is seen through the glass. Paint the brushes using simple, flat washes.

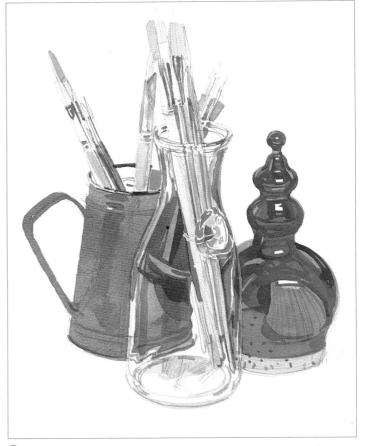

8 Finish by drawing in details with linear brush strokes, and sharpen by reverting to the pencil, tightening some details and adding a little loose shading.

Fur and Feathers

We could add "hair and foliage" to this title, because they present much the same problem—how to represent a texture that is composed of hundreds, thousands, even millions, of tiny elements.

SEE ALSO:

• Sharp edges in line, page 20

• Rounded objects with tone, page 26

• Standing nude, page 132

The answer, of course, is to see them as groups or collections of small components that together make a surface. Fur is composed of millions of individual hairs, but seen on a furry animal they make a softer version of the skin beneath. Only where hair is very sparse should you try to draw individual hairs; for the rest, look for overall form, with perhaps some indication of direction of growth. Glossy fur may have highlights, too, that can help you to see the form. Human head and facial hair needs to be treated in much the same way.

Feathers are a somewhat different case. Although the separate feathers are made up of very small, interlocked components, each feather presents itself as a precisely shaped object; on the bird they are specialized into different types, according to their function. A bird's wing is a wonderful mechanism. When spread, you can see that there is a precise pattern of placement of the different types and sizes of feathers, and it is this pattern that you must bring out.

ANIMAL VARIETY

The gulls' feathers (top) are only suggested in the bulk of the bird, while coarse and smooth hairs (above and left) show the contours below the skin.

Materials
4B pencil
Heavy drawing paper
Scrap paper
Soft putty eraser

1 Begin by establishing the basic shape with a loose outline sketch. If the subject is very small, do not be afraid to work much larger than life.

2 Observe the different areas of changing texture, and lightly define these in the drawing. Delineate the wing's feather structure.

3 Draw the fluffy back and head feathers, noting how these are very different from the more obviously structured flight feathers on the wing. Look for the patterns in the feathers, and indicate these with linear drawing. Add color tonally by soft, crosshatched shading.

4 Begin drawing the tertiaries—the top row of flight feathers. These are smaller and softer than the subsequent two rows (the primaries and secondaries). Use the texture of the paper's surface to enhance the textural patterns in the drawing. Where a deep black is required, don't be afraid to "crush" the paper's surface with the pencil point.

5 Add further detail to the back feathers, and then move on to the tail feathers. Linear crosshatching in pencil is an ideal technique for describing the texture of feathers. Use a piece of scrap paper to protect the drawing from being smudged once it arrives at an advanced level of execution.

6 Keep the pencil point sharpened at all times so that you can achieve fine lines. Even when drawing very dark areas of feather, let your pencil follow the structural make-up. Use a variety of line weights to describe the richness of textural changes.

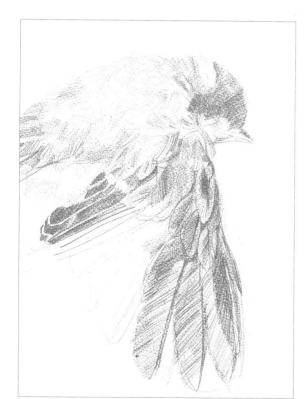

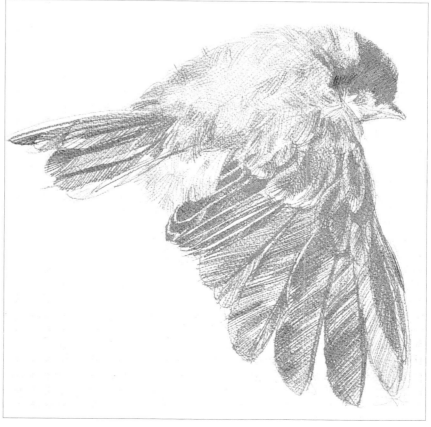

7 Draw in the primary flight feathers, emphasizing strong, positive shapes and smooth surface detail. They have almost no vane on their leading edges.

8 Complete the drawing by finalizing the dark secondary feathers and the unfinished primaries, looking constantly at the structure of the quills. Deepen the darkest blacks in the fur-like feathers around the head, leaving hardly any of the paper's original surface texture. Use the putty eraser to clean up any graphite smudging around the drawing.

Fabrics

The texture of cloth is inextricably linked with the way it folds and falls. Coarse fabrics tend to have angular folds and flatter surfaces, while soft, sheer fabrics tend to stretch and flop into fluid shapes.

Heavy woven or printed textiles require you to make a choice—whether to treat the weave or the pattern as a randomized texture, or to describe the pattern more precisely. If the weave has a large regular pattern—as a tartan, for example—it may be necessary to draw it quite precisely. Similarly, a printed fabric with a large repeated motif, or a broad striped material may have to be observed and described relatively completely. Although you may find this arduous and demanding of your patience, there is the added advantage that the distortions in such patterns made by the folding and stretching of the fabric actually help to describe the form.

More generalized textures can be simulated by various methods such as dry brush, stippling, spattering, scratching back, or even using ink or paint on cloth samples to print its weave on your drawing in selected places. This last can be very effective if you choose a weave of the correct scale, and print it only on the light receiving surfaces, leaving the shadows as even tones.

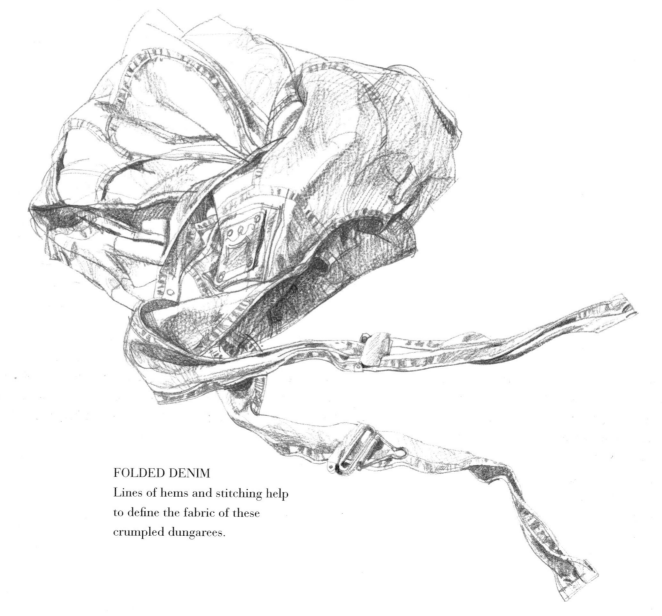

FOLDED DENIM
Lines of hems and stitching help
to define the fabric of these
crumpled dungarees.

Materials
Drawing paper
Steel-nib dip pen
Red-Brown waterproof ink
Bamboo pen
India ink
Clean water
Scrap paper
Hobby or utility knife

1 Loosely sketch in the main shape of the cloth, using a very dilute mix of brown ink and the steel pen. Use the scrap paper to check constantly the quality of the ink on the pen. Although this exercise is primarily about texture, observe how the linear weave of the cloth also describes form, and follow the rhythms of the weave.

2 Start building up texture immediately using patterns of line and stipple that emulate the rough, woven quality of the cloth. Dip the bamboo pen in the black and brown inks alternatively to get a range of tones, and lightly dip the pen in the water to reduce the intensity of the ink's color.

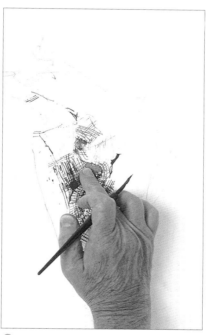

3 Use the tip of a finger to dab wet areas of ink drawing and spread the textural qualities in a chance, almost random way.

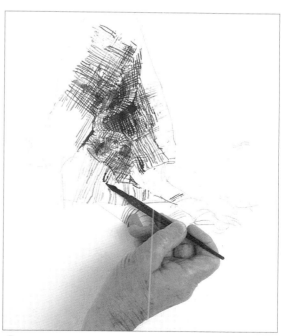

4 You can get a further variety of pen width by holding the steel-nibbed pen at a very low angle to the paper, and drawing with the back of the nib rather than its fine point.

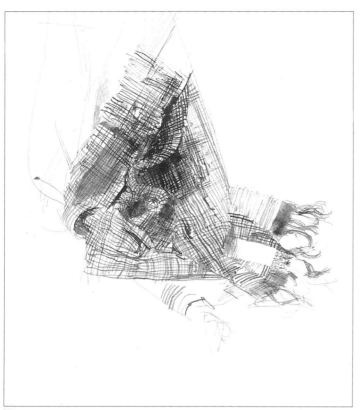

5 The pattern becomes alternately darker and lighter just before the fringe at the end of the scarf. Represent the light panels by dots, and the darker ones by close crosshatching.

6 Reinforce the shadow areas by scrubbing on dilute gray ink with a dry brush. If a shadow becomes too black, use a sharp hobby knife to scratch some lighter spots to break up the solid patches.

7 Your aim in such an exercise as this should be to take the opportunity to discover what marks can be made with pens and ink. If the drawing should go irretrievably wrong, don't worry, just treat it as a learning experience.

Water

SEE ALSO:

• Glass,
 page 60

• Boats and jetty,
 page 100

• Gorge and river,
 page 108

Like glass, water is transparent, reflective and refractive. Unlike glass, it may be mobile, either constantly, as in river flow, or repetitively, as in breaking waves, or explosively, as in fountains, waterfalls or spouts.

Completely still water behaves as a mirror, faithfully reflecting its surroundings. Ripples on water cause reflections to break up and lengthen, so that a single point of light may be reflected as a broken vertical line extending down the full depth of the water surface. As the water becomes more disturbed, reflections may be so fragmented that they are hardly visible at all.

Falling water, although moving too fast for the eye to follow individual droplets, makes characteristic shapes that you can describe and animate, with the lines indicating the flow. The same applies to flowing water in a river or stream—though this is constantly on the move, the patterns repeat, so that by observing closely you can draw a sort of average of the movement. By shifting focus a little, it is often possible to see through the flow patterns to the pebbles and rocks on the stream bottom.

Waves breaking on a shore are also repetitive, but over longer periods. In order to freeze this action you need to concentrate on one part of each wave at a time. For example, if you watch and draw a little of the shape every time each successive wave just peaks and is ready to break, you will eventually have a complete wave at that stage. You can then do the same with a further stage, perhaps as the wave curls, and then again as it explodes on a rock, and so on until you have a complete sequence of drawings.

The refractive quality of water is clearly seen when the stems of flowers in a glass vase are apparently dislocated and shifted sideways at the point where they break the water surface.

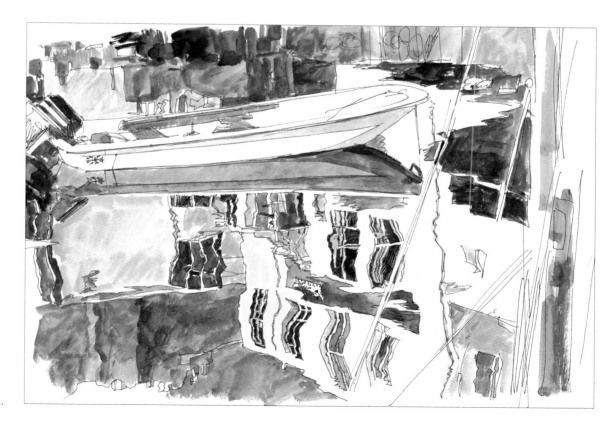

REFLECTIONS
The distorted reflections in this relatively calm water are still clearly recognizable as upside-down buildings.

Materials

Dark-colored pastel paper

Pastels

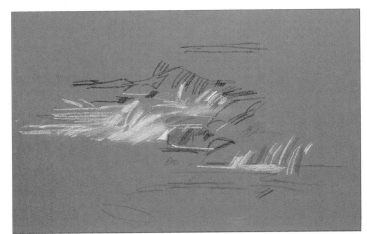

1 Working on a fairly dark paper, make the compositional marks with a light-colored pastel. Make these light shapes quite broad, as you can easily modify them later.

2 Draw some lines to indicate the dark rock forms. It is better not too make these too solid at this stage, because it is more difficult to overdraw dark shapes with light ones than vice versa.

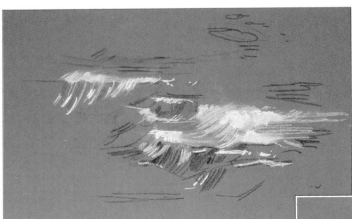

3 Consolidate the main light areas, and then follow the progress of the water as it spills over the rocky ledges to the lower levels. I have not always specified exactly which color pastel to pick up because, of necessity, your view of a similar subject will be just that—similar—but not exactly the same. You must trust your judgement at the time. Remember, that it is not always possible to have exactly the right color to hand—mix where possible, but ultimately use what you have.

4 In some places the water separates as it spills over the rock edge, and in other places it holds together in one curved sheet. While the color paper chosen for this drawing needs to be completely covered to depict the fast-flowing water, it is a good color for the basis of the color of the river bed seen through the unbroken water.

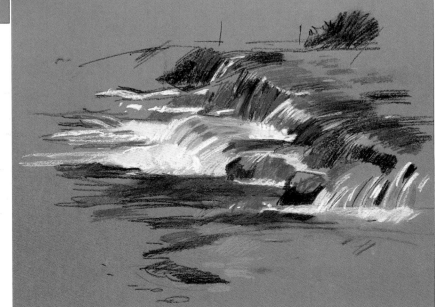

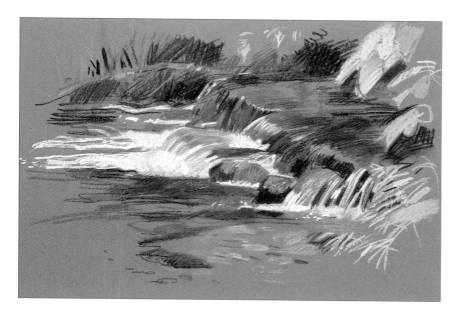

5 To put the fast-flowing water in a context, draw in some of the far bank and the near ferns and tree branches that frame your view, and add more darker tones to the far bank to define the foreground leafage.

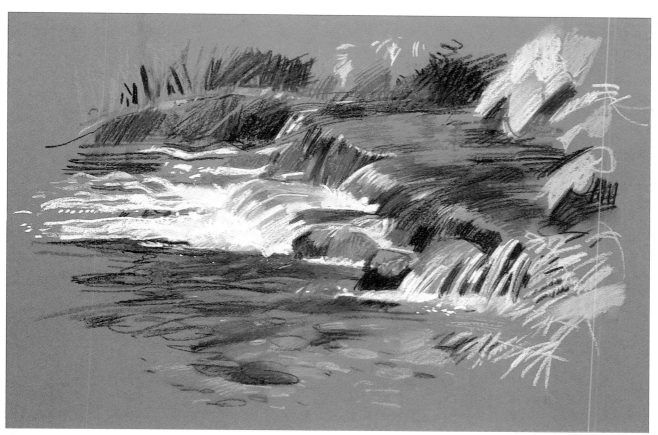

6 Add color to the foreground to represent the river bed glimpsed through calm water—the fast, smooth water at the far bank has both reflection and transparency. Finally, add the white of the broken water, and strengthen it with pure white.

PRACTICING *your Skills*

In this section a number of longer, more complete, drawing projects are followed through their initial stages and further development to completion. The principles and skills demonstrated in the first section are brought into play, and are cross-referenced where useful.

Every artist has his or her own response to a subject—never think that there is only one approach and technique. My intention is to show how I have put together a drawing, and to invite you to try a similar technique, to see whether it enables you to get what you want from a drawing. I also hope to impart the thought processes involved, because these are as important as the marks you make.

Much depends on what you need from a drawing. You may want to gather information for later use, or you may, from the outset, aim for a drawing that stands on its own and says all you want to say about your subject in a striking or beautiful manner. Perhaps all you need or have time for is a fleeting impression, an *aide-memoire*. In each circumstance you must find the best mode of working for you.

These pages offer you some choices. Try some of them ,and also use the insight you have hopefully gained to analyze the methods of other artists.

Whenever possible, it is much more rewarding to draw in front of the real thing rather than a photograph of it. Then, when there is absolutely no alternative but to resort to photographic reference, you will have a better idea of what information to select or reject.

Flowers in Vase

PRACTICING YOUR SKILLS

For this project, choose a few flowers that have simple, strong forms, and group them together in a vase decorated with an uncomplicated design. Add leaves or other stems to complement the flower forms.

The point of this study is not to analyze a type of flora, but to make a drawing of an arrangement of flowers and vase in an informal setting. By this, I mean that you should not try to construct a competition flower arrangement, but aim instead for a natural grouping, the sort of group into which a bunch more or less arranges itself.

Before starting to draw, examine your arrangement from different viewpoints by rotating the vase. Choose a view in which one bloom or group of blooms catches the eye. Try to find something about the grouping that interests you—it may be a splash of color, or a strong line, or the overall silhouette of the subject against the background.

Your drawing will always be better for taking a little time to look at the subject and let it speak to you. This means that you need to have an idea, a response, to the subject you are about to draw. It may be vague and it may become clearer as you work, but if you begin with absolutely nothing in your head at all, your drawing is likely to be empty too.

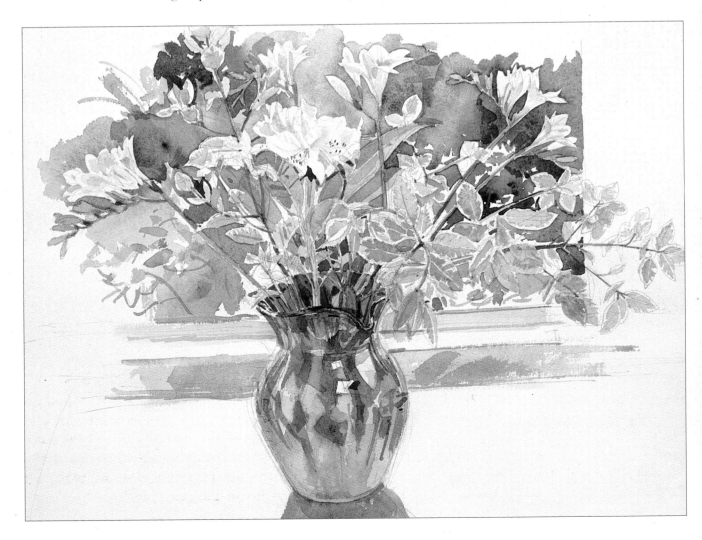

Materials

HB and H pencils
90lb (180gsm) cold-
 press watercolor
 paper (stretched)
Medium Chinese brush
Clean water
Watercolors:
 Viridian, Chrome
 Yellow, Raw Umber,
 Ultramarine
Soft putty eraser

1 Begin by plotting, in HB pencil, the main elements of the composition—the flower heads and stems, and how they relate to the vase. Map out the composition's overall, two-dimensional shape, making sure that you keep to the same viewpoint throughout.

2 Define the spout. Then draw a piece of foliage nearest to you and work backwards into the rest of the group of flowers. Try to avoid correction at this early stage—if any marks are obviously wrong, don't delete them until you have drawn the correct ones, otherwise you may find yourself simply repeating the same mistakes.

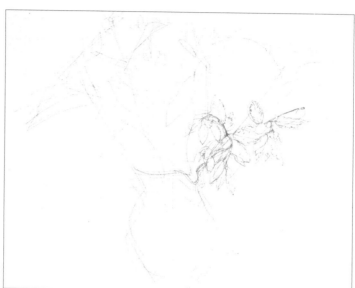

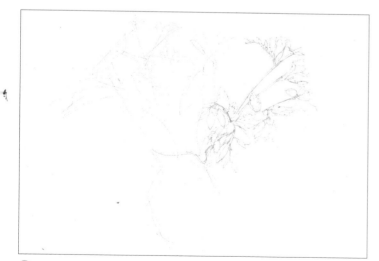

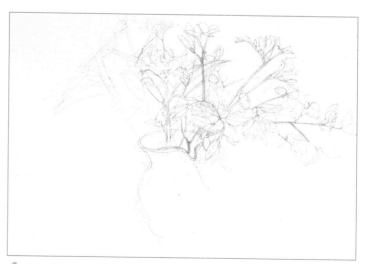

3 Use the slightly harder H pencil to delineate the plants where the color changes are most subtle. Delete any original plotting lines when they become redundant and only serve to confuse. Pay careful attention to the drawing of the white flowers, because there is little else to help define them.

4 Observe the character of the flowers and foliage, and how they grow—note how the gently curving freesia stems contrast against the woody angularity of the pittosporum, and how the papery delicacy of the rhododendron flowers contrasts against the waxy heaviness of the leaves. Continue to build the pencil drawing, still working from front to back.

Taking Stock

Finalize the pencil drawing, checking that each new area of marks is correctly related to the rest of the composition, and amending where necessary. You will find your confidence increasing as the drawing "grows." Reinforce the line work on the nearest elements to bring them visually forward in the picture. Finish the drawing by adding detail to the vase.

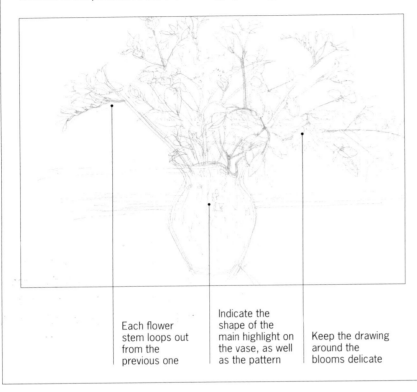

Each flower stem loops out from the previous one

Indicate the shape of the main highlight on the vase, as well as the pattern

Keep the drawing around the blooms delicate

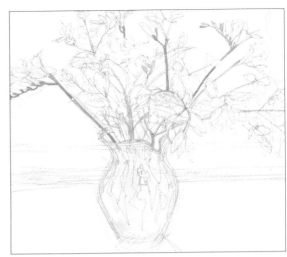

5 In this type of pencil drawing with added color, involving little or no building up of overlaid washes, the applications of washes need not follow any particular order. I started with the stems of the freesias and other greenery, so that I could later erase some of the pencil drawing, making it easier to establish the more delicate white flowers.

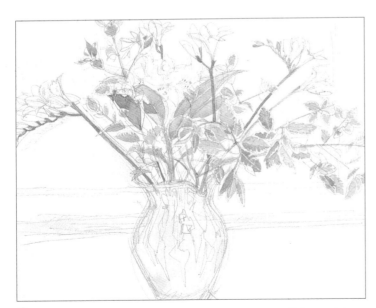

6 Using a Viridian wash softened with a little Chrome Yellow, add color to the foliage. Work over the drawing, observing the subtle changes of green hues. Vary the wash by altering the ratios of Viridian to Chrome Yellow.

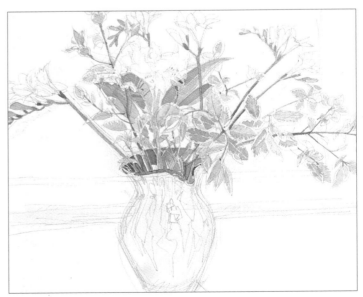

7 Mix a darker tone of a more neutral green by adding Raw Umber to Viridian, and use this to to define the brownish plant stems. Lay a greener version of this wash for some of the darker tones on the leaves, and to define the dark tones of the vase's interior. Take care not to obliterate the whites or the previously applied light tones.

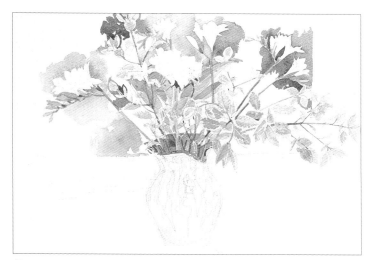

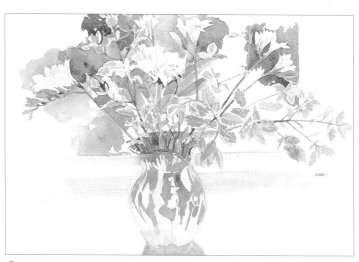

8 Use the eraser to knock back the pencil work around the white flowers, but do not obliterate it completely. With a Raw Umber and Viridian mix float in the background color, placing the white flowers into sharp relief. Mix Chrome Yellow into the wash to give a broken color effect. Keep the wash wet and fluid, and the board flat.

9 Add color to the pattern of the vase—the apparently abstract patterns describe its form by following its shape. Using a very pale mix of Ultramarine with a little Viridian add the shadows on the insides of the flowers. Use dilute Chrome Yellow to color the point where the freesia flowers meet the stem. With a cool wash, give an indication of background shadow to place the flower arrangement in context.

10 Use a wash of Chrome Yellow with a little Raw Umber to define the white flowers. Further shape the windowsill, and allow the background washes to run into each other, to show the softer-edged pattern on the vase.

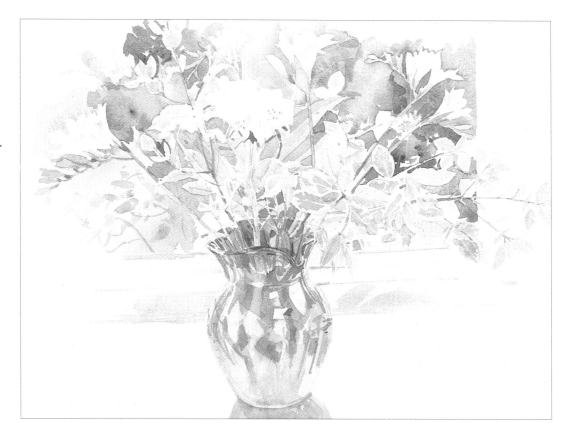

Fish and Shellfish

This setup would also work well out of doors, with ropes and seeweed.
The flat planes of the fish contrast with the complexity of the prawns.
The combination of natural and man-made objects provides texture.

SEE ALSO:

- Sharp edges with tone,
 page 24

- Ellipses and cylinders,
 page 32

- Using color,
 page 42

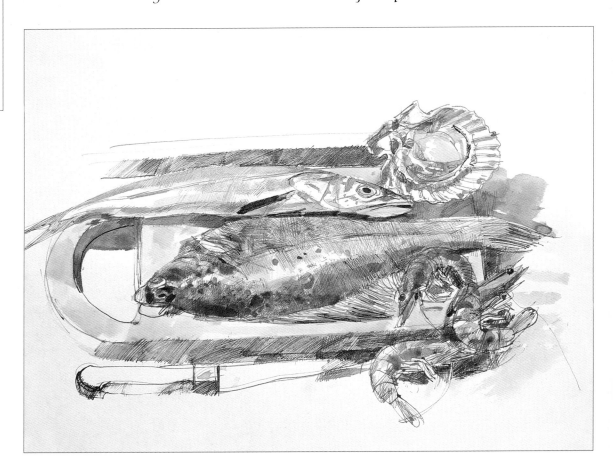

Drawing fresh fish requires you to work quickly before the sheen on the scales grows dull. For longer working time you could substitute shellfish, which do not change their appearance quite so quickly.

A trick used by photographers is to keep food subjects looking fresh by wetting them with a fine spray of water. Brushing a fish with glycerine works well, too, and if your drawing continues into a second day, you can refrigerate the fish.

Eventually however, the fish will begin to become rather smelly, so it really is essential to inject a little more urgency than usual into the way that you work. Of course, you can record the subject in a photograph if you really run out of time, but it is not easy to capture the full subtlety of color in fish scales on film. Even small changes of viewpoint reveal shifting nuances of sheen and transparency that you can incorporate at will when you are looking at the real thing; in comparison, the photograph is static.

Shellfish retain a fresh appearance much longer than fish do, and are marvellous subjects. Crabs and lobsters have beautiful, rich colors when they are alive—rather less so when they have been cooked—but you may feel, as I do, that it is rather cruel to keep them alive just for your drawing pleasure. In this case, I would prefer to record their natural beauty with the camera, and make the final drawing from a photographic print. Choose a background for your fish that is not too strident in color, but that provides a gentle contrast of texture and color.

Materials

Steel-nib dip pen
Medium Chinese brush
Heavy drawing paper
Clean water
Colored inks:
 Carmine, Orange,
 Sepia, Burnt Sienna,
 Yellow, Ultramarine,
 Black
Scrap paper

1 Arrange the still life to your satisfaction, then work with diluted Sepia and Ultramarine to quickly sketch the basic outlines of the arrangement with the pen. Keep the colors pale during the early stages of the drawing—you can always darken them later.

2 Begin working on the thin fish (the hake) using a dilute Black ink, adding crosshatched detail with the Black and with dilute Ultramarine. Using the Chinese brush, wash in some light tones of broken color over the body of the fish. Quickly drop in some of the simple detail on the flat fish (the plaice), and the scallop shell.

3 Continue to build up finely hatched details with watery tones of Sepia, Black and Burnt Sienna. Test the colors on scrap paper first. Leave white paper shining through to emulate the highlights on the fishes' luminescent skin. Treat the other elements in a similar fashion.

4 Use dilute Carmine, Yellow and Sepia, both as washes and as hatching, to build up the delicate coloration of the two fish. Use the direction of the hatching to follow and indicate form. Use the brush to draw in softer, but broader line work, such as the tail of the flat fish.

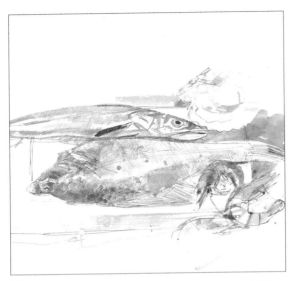

5 Using the brush and lightly diluted Orange, add the glowing spots on the flat fish's body. Continue to work over the whole of the drawing in both line and soft wash, gently building up detail and definition. Using darker, stronger inks, such as Burnt Sienna, Sepia and Black start to heighten details, such as on the prawns. With a dilute mix of Black and Ultramarine an indication of the windowledge was added.

Taking Stock

Brush in a color wash on the chopping block, and using a warm, dark mix, float in some of the major areas of the deeper cast shadows.

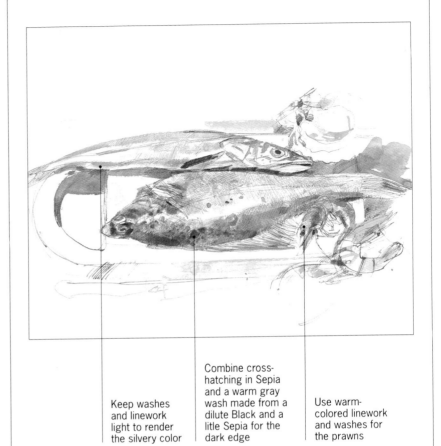

Keep washes and linework light to render the silvery color

Combine cross-hatching in Sepia and a warm gray wash made from a dilute Black and a litle Sepia for the dark edge

Use warm-colored linework and washes for the prawns

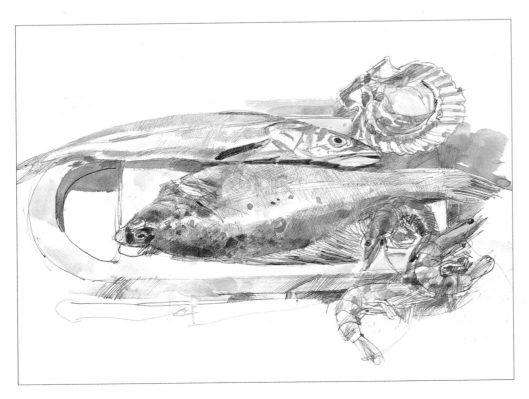

6 Using a fluid mix of Orange and Carmine, build up more detail on the prawns' shells. Use darker mixes to accentuate the detail. Treat the scallop in a similar fashion using Yellow and Sepia as well.

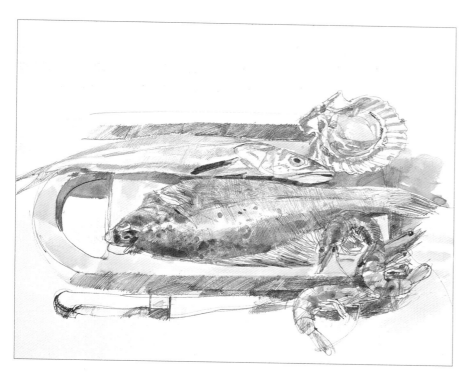

7 Here, using a mixure of Black and Sepia, I added an indication of the window edge that supports the scallop. Check for anomalies by viewing your drawing in a small mirror.

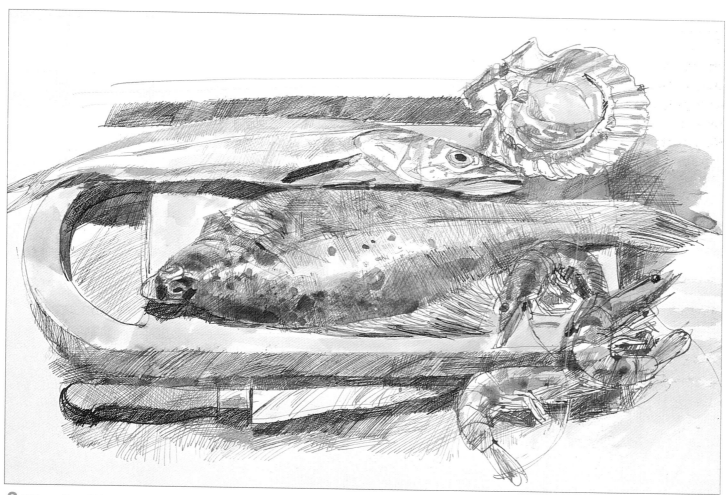

8 With undiluted black ink, add the shading on the knife handle, then darken the shadow around the knife to throw it into relief. Finally, add the shadow around the board.

Fruit and Vegetables

The intention here is to create a still life with a rich mixture of texture and color. When selecting your objects, look for a mix of smooth and textured natural forms, and man-made pattern.

SEE ALSO:

• Rounded forms in line, page 22

• Rounded objects with tone, page 26

• Using color, page 42

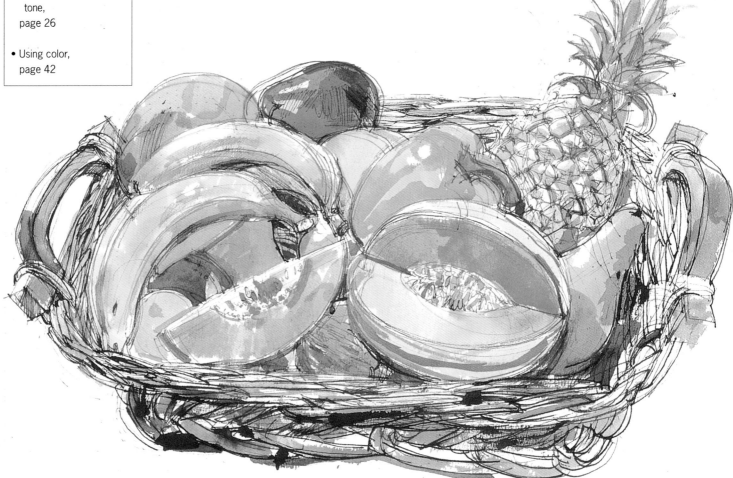

There is inevitably some measure of contrivance in still-life arrangements, but I try to make it look as natural as possible. There is an argument for not trying to do this, for accepting the artificiality of such arrangements and making a virtue of it. You must make up your own mind which approach you prefer.

Whichever approach you choose, the first thing to do is to gather together a good-looking mix of fruit, vegetables, various pots and utensils, a choice of fabrics and so on, and then to find a spot in which to arrange them where the light will be reliably constant.

Most artists prefer to work by indirect daylight, which produces relatively soft-edged shadows, but others prefer the harder lighting afforded by tungsten light bulbs. Again, it is up to you to make the choice.

Take some time to look at your chosen grouping, and don't begin until you are happy with the composition. Make a few compositional sketches before deciding on the final arrangement.

In this project I have tried to limit the color range of the whole composition, while choosing objects that are subtly different in shape and texture.

Materials

Steel-nib dip pen
Waterproof inks:
 Burnt Sienna, Yellow,
 Orange, Sepia,
 Bright Green,
 Carmine, Ultramarine,
 Black, Blue
90lb (180gsm)
 cold-press water-
 color paper
No. 3 sable brush
Clean water
Scrap paper

1 Using the pen and a dilute mix of Burnt Sienna, plot the basket's outline and the shapes of the fruit, making a sympathetic color basis for the arrangement, which is mostly hues of green and yellow. Use more specific colors to help identify the different objects in the composition. Describe the basket's subtle perspective, working from left to right and from front to back. Keep a piece of scrap paper handy to test the density of diluted ink from time to time.

2 Still without making too firm a statement, define the silhouettes of more fruit, such as the mango and bananas, using Yellow and Orange inks. Analyze and use the negative and positive shapes within the composition, correcting and adjusting the outlines as you do so.

3 Having defined the basket's basic outline, begin to describe its weave with a mixture of Black and Sepia.
 Inset: To accurately follow the intricacies of the basket weave, analyze the structure, rather than just the pattern.

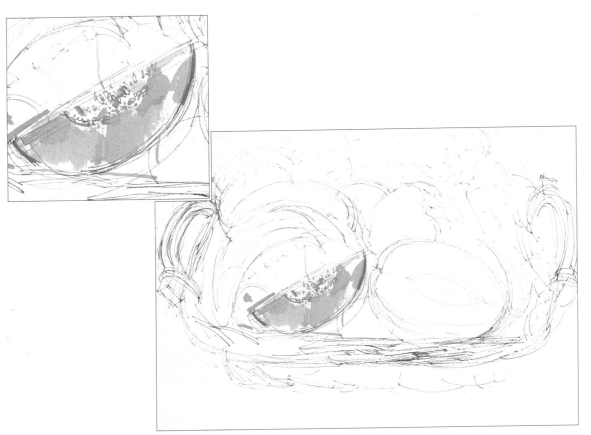

4 Using both brush and pen, add detail to the slice of melon, diluting the Orange ink to flow on a wash of color.

Inset: Define the melon pips with the pen, and use the different colored inks to reveal the variety of colors in each fruit.

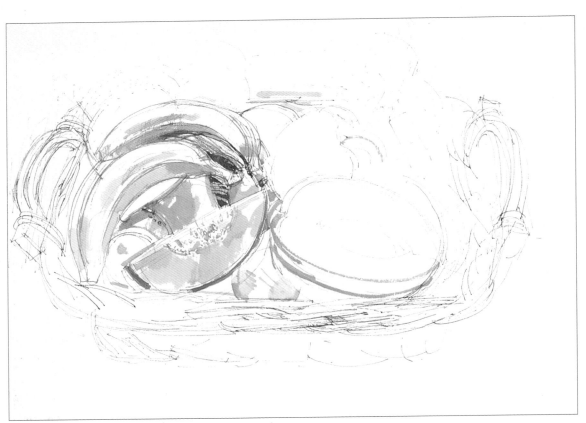

5 As the shapes of the fruit become more explicit, take care to keep to a constant viewpoint—any slight change of position will radically alter the visual relationships of the fruit to each other. Use both pen and brush to work in line and wash alternatively. Soften the Bright Green with Yellow to add a wash to the skin of the pear.

6 Mix a dull olive from Yellow and a little Black, and start washing in the color of the basket. Use Orange heightened with a touch of Carmine to flow in some color on the flesh of the main melon section. Draw the seeds using a mix of Orange and Yellow blending into each other.

Inset: Soften too strong lines by touching them with a finger while they are still wet.

Taking Stock

Continue to further define fruit shapes, constantly observing and adjusting as needed. Alternate between Bright Green and Burnt Sienna to draw the pineapple's pattern.

Use watered-down Carmine and Yellow line to indicate the light pips

Strengthen the first exploratory lines of the basketwork

7 Using the pure Yellow, brush on a color wash over the bell pepper, leaving a highlight of white paper showing through. Do the same for the bananas using a paler, more dilute wash. Add a tiny touch of Bright Green to the Yellow to give a more acidic hue for washing over the lemon. Add tone by cross-hatching to strengthen the drawing of the basket and its handles in Sepia.

8 Using the pen, define the edges of the red pear and mango at the back of the arrangement, and use the brush to add color areas, leaving them loose at this stage. Work across the drawing, sharpening the detail. Add a little Ultramarine to a dilute Bright Green to give a cooler green for the melon skin, and begin to define the forms of the fruit with tonal washes.

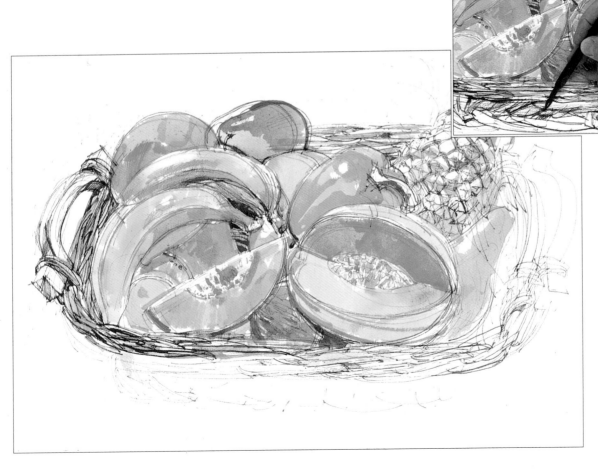

9 Now that the overall drawing is firmly established, draw freely and boldly, utilizing the adaptability of the pen nib to give various weights of line.

Inset: Using Sepia, draw into the basket weave.

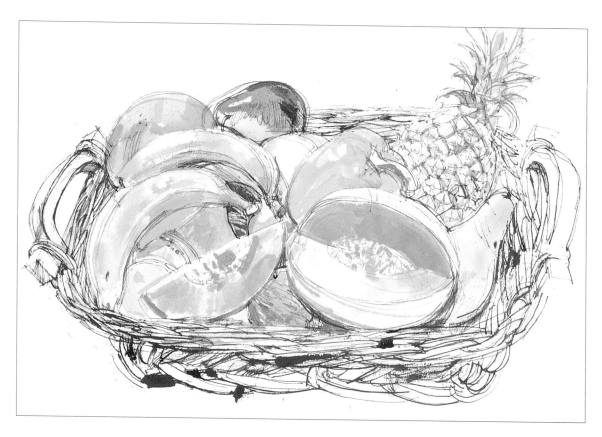

10 Using a blend of Blue and Bright Green, add color to the pineapple leaves with the brush. Draw into the still-wet wash with the pen and a darker tone of Bright Green, allowing the line to bleed slightly and produce interesting effects. Use Black to accentuate the drawing of the basket, obliterating any paler, incorrect line work. Use the tip of your finger to spread wet ink into descriptive marks.

11 Mix Carmine, Yellow and Black with a little water to make a brown wash to color the basket. Use a dilute mix of Black for the cooler-colored handles, and add a touch of Blue to this to give a cool, shadow color.

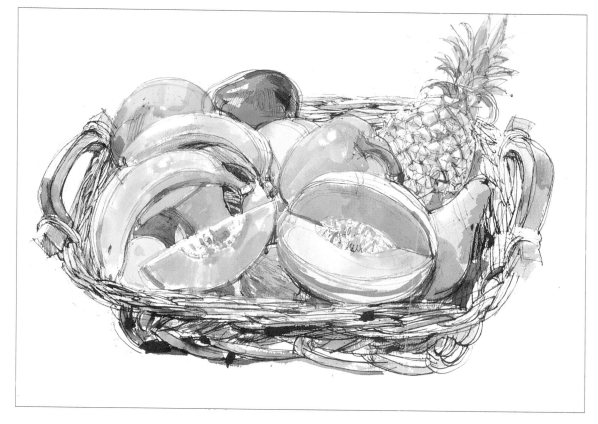

Glass Bottles

The purpose of this project is to allow you to explore reflective, transparent objects and the interactions between them. Some elements are seen through other objects, and others are reflected in their neighbors.

SEE ALSO:

• Sharp edges in line,
 page 20

• Ellipses and cylinders,
 page 32

• Glass,
 page 60

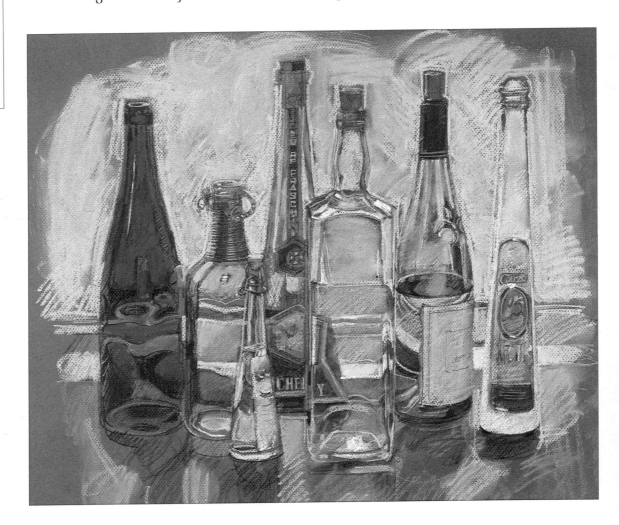

A clear glass object exists visually by what is seen through it and what is reflected from it. Even if the transparent material (it may not be glass) is colored, thus defining its outer silhouette, its volume and form is readable only from reflections of surrounding objects, views of other objects seen through it, and any judgement that can be inferred by pattern on its surfaces. All these interactions can make rich patterns that, when examined closely, often reveal distorted but otherwise recognizable versions of their surroundings.

Nowhere is objectivity and subjectivity so clearly demonstrated as in a collection of shiny and transparent objects. Subjectively we are able to read that an object is shiny and we can deduce something of its shape and volume intuitively. But what are we actually seeing objectively? We see a distorting mirror image of the surrounding objects, and from the degree of distortion we deduce the nature of the form that is making the reflection.

Where reflections are compressed in one direction we are able to read a form that is turning away, an edge. As the reflections become fatter we read a more rounded convex shape in the middle of a form. All this is done subconsciously, but if we are to draw these images we have to look more intensely, that is, objectively.

Materials

Blue Canson pastel
 paper

Pastels:

 White Conté, Pale
 Viridian, Crimson Lake
 Tint 6, Cobalt Blue
 Tint 2, Blue-Gray Tint
 4, Cadmium Yellow
 Tint 1, Silver White,
 Lemon Yellow Tint 6,
 Yellow Ocher,
 Hooker's Green Tint 5,
 Ultramarine Tint 8,
 Davy's Gray

Charcoal pencil

White Conté pencil

Scrap paper

Fixative

Opalescent tracing
 paper and mat (mount)

1 Find the center of the composition by looking at the tops of the bottles—here, the square-section eau-de-vie bottle. Plot the overall shape with the White Conté pastel, making guide lines to mark the relative heights. As the composition takes shape, strengthen the white lines and establish the leading horizontal line.

2 Define the eau-de-vie bottle with the White Conté pastel. Draw in some green highlights with Pale Viridian, and add some of the bottle behind with Crimson Lake Tint 6. Mix Cobalt Blue Tint 2 and Viridian to draw in some of the shapes in the bottle's base. Use the charcoal pencil for linear definition of the rear bottle's label, and draw part of the window frame with Blue-Gray Tint 4.

3 With the charcoal pencil define some of the sharply delineated shapes, and outline the hard-edged shapes that appear through the glass. Fill in the shapes with White Conté and Pale Viridian, then strengthen the outlines with charcoal pencil. Use a pale rendition of Cadmium Yellow Tint 1 for the label, and add the lettering with charcoal pencil. Use the Silver White pastel for the bottle's shoulders.

Inset: Use scrap paper to protect the drawing.

4 Modify some of the color areas with the charcoal pencil, and define the bottle's neck. Add some of the highlights in the neck using the White Conté and Pale Viridian, keeping their outlines as crisp as possible. Use the charcoal pencil to define the vague reflections in the neck. With Cadmium Yellow Tint 1 draw the cork where it catches the light, and use a mixture of Lemon Yellow Tint 6 and charcoal for the part of the cork in the bottle.

5 With Cadmium Yellow Tint 1 and Yellow Ocher, draw the label on the liqueur bottle, and modify it with charcoal. Use Crimson Lake Tint 6 for the liquid highlights, and darken the shadows with charcoal. Add the lettering on the neck with Yellow Ocher and charcoal, drawing patterns rather than letters. Use White Conté, Black and Pale Viridian for the label.

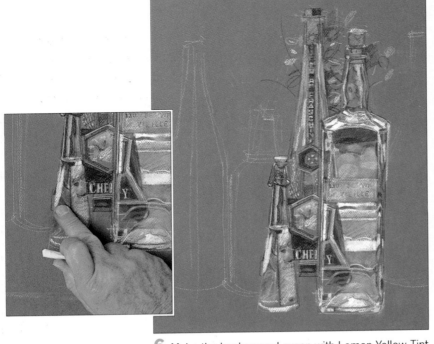

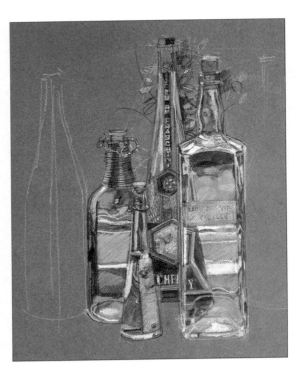

6 Make the background green with Lemon Yellow Tint 6 and charcoal. Draw the olive oil bottle with Lemon Yellow Tint 6, which acts as a basis for the pure hues of the highlight areas. The label is Cadmium Yellow Tint 1, with detail in Hooker's Green Tint 5. Fix the drawing.

Inset: Soften and blend areas of tone with a finger.

7 Draw the basic outlines of the cylindrical bottle using the charcoal pencil, then use White Conté and Blue-Gray Tint 4 to draw the main areas. On the shoulder draw the small reflection of a skylight in White Conté, and sharpen it with charcoal. Draw the basic cone of the wire collar in charcoal, then add highlights and define the wire with the White Conté pencil. Add the colored beads.

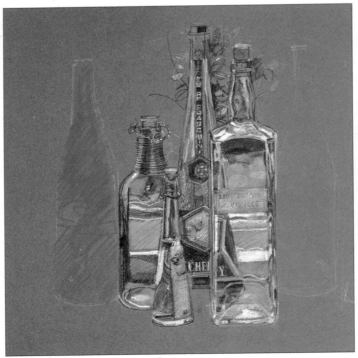

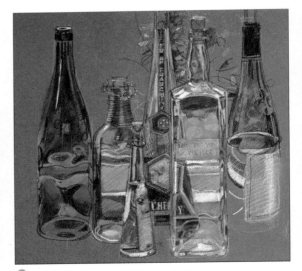

8 Use the Ultramarine Tint 8 to establish the overall color area of the blue bottle. Though this is a very bright color, you can modify it, and the pure blue, as with the lemon yellow on the oil bottle, will ultimately exist only in the highlight areas.

9 Work in the dark blue areas with charcoal, and use White Conté for bright, reflected light. Draw the distorted image with Blue-Gray Tint 4, highlighting the rim with White Conté. Use the Lemon Yellow Tint 6 to draw in the meniscus of the liquid in the wine bottle, and add other highlights. Mix Hooker's Green Tint 5 and charcoal to block in the main bottle. Use Cadmium Yellow Tint 1 to block in the label, then rub down to reduce the tone.

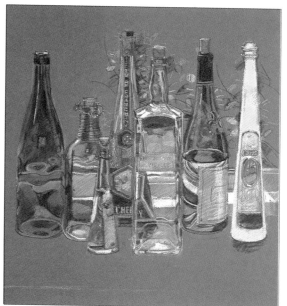

10 Sharpen the lines with charcoal. Add the last bottle using Lemon Yellow Tint 6 with a little Cadmium Yellow Tint 1. Sharpen detail and add the label with charcoal, where the highlights are. Draw the undistorted window frame, and add a degree of soft background detail to push the bottle forward.

Taking Stock

At this stage I felt that the diverse range of bottles, different shapes, colors and surface textures was creating a very disparate composition, confused further by the background. I gave the drawing a coat of fixative, and then taped a piece of opalescent tracing paper over the window, softening the light and reducing the background to a soft, flat tone.

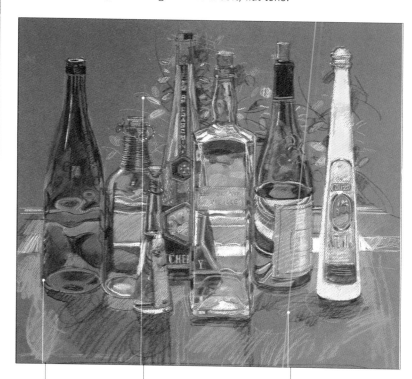

Redefine shape and detail with charcoal

The background leaves complicate the composition

The surface is blocked in with Blue-Gray Tint 4 and charcoal

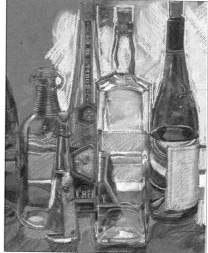

11 Modify the light coming through the bottles using a range of pastels, but mostly in White Conté and charcoal, lightening and amending every bottle except the yellow one on the right. Lighten the base surface using Davy's Gray.

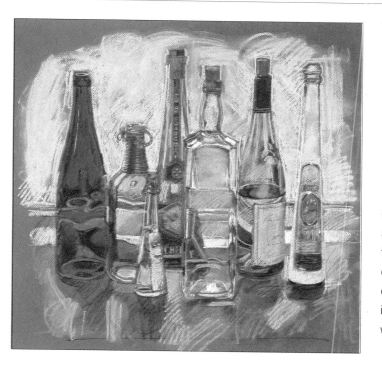

12 Reassess the whole drawing and make final additions. Cut a mount from paper and place it over the drawing to check the extent—increase the background where needed.

Bicycle

What is it about a bicycle that so confounds visualization? It is astonishing how few people can, from memory, draw the basic structure of a machine that is a familiar feature throughout the world.

SEE ALSO:

• Ellipses and cylinders, page 32

• Lawnmower, page 38

• Metal, page 58

Here, I refer of course to the traditional frame—there are a number of radical departures from this shape nowadays, including bikes on which the rider adopts a prone position, the so-called recumbents. But the vast majority of bicycles still adhere to the original principles—open structures where all the basic functions are visible—and this makes them wonderful to draw. There is something curiously satisfying about a design that can withstand the passage of time as the bicycle has, form following function to produce a thing of beauty.

Although a bicycle is a machine with a precise geometry, involving a rigid tubular frame containing axles, cogged and spoked wheels and so on, which may suggest the need of description by precise technical drawing, there is really no reason why you should not explore the patterns of ellipses and triangles in a much looser and more spontaneous style of drawing.

A linear medium is probably the best choice for rendering such a collection of tubes and wires—I used pen and waterproof ink for this drawing of my beloved, custom-built Roberts.

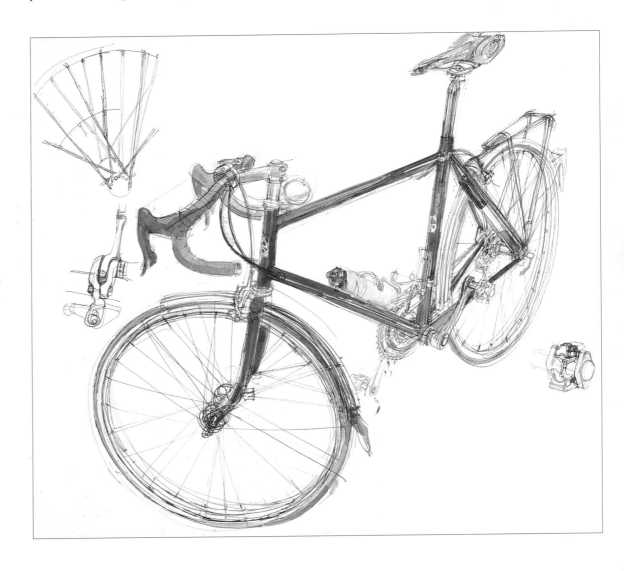

Materials

Steel-nib dip pen
Drawing paper
Clean water
Waterproof inks:
 Black, Red, Yellow

1 Make the first marks either fragmentary or fugitive, or use a mixture of the two. Use watered-down ink for roughing out the main long elements.

2 To ensure a constant watered-down tone, you can keep dilutions in small containers—the canisters that 35mm films are sold in are ideal. Use dark ticks or dots to indicate the smaller interstices.

3 After sorting out the general proportions, start on the more specific shapes using less diluted ink. I like to begin from somewhere near the middle of the drawing, and work out from there. Note that the bottom bracket (the axle of the pedals) is parallel to the back wheel axle.

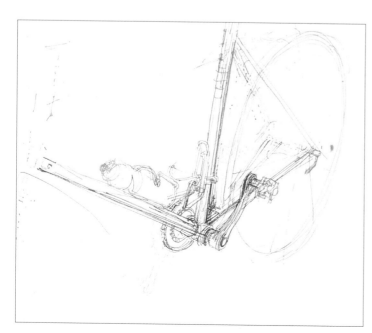

4 Next, draw in the two bottle cages, one containing a water bottle—these partially obscure the triple chain set on the other end of the bottom bracket. As you add details, use the spaces they occupy to assess the directions of the frame tubes.

5 Now draw the two pairs of thin tubes that hold the back wheel (chain and seat stays), the short handlebar stem and the cross bar that completes the shape of the main frame. Don't draw all the links in the chain and every tooth on the chain wheels, but make the ellipses lie in the right plane, with major axes at 90° to the axles.

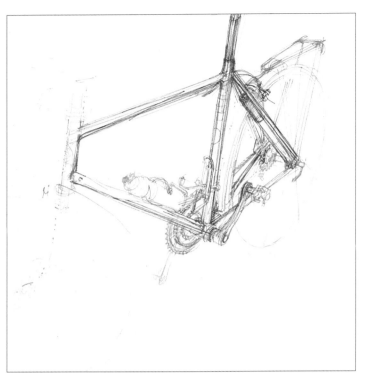

6 When you arrive at the curved form of the saddle, carefully observe its shape—it is very easy to become involved in its panels and lettering, and to draw it too large.

7 The front wheel and the handlebars of a bike can pivot freely, and as a result, any parallels in the handlebars—lines joining the tops of the brake shrouds, the bottom ends of the bars, the straight part of the top of the bars—all vanish to a different vanshing point from the other two axles, the bottom bracket and the rear wheel axle.

8 The front wheel axle points to the same vanishing point as that of the handlebars, so the major axis of the front wheel ellipse (always at right angles to the axle) is in this case nearly horizontal—not vertical, as it is often thought to be.

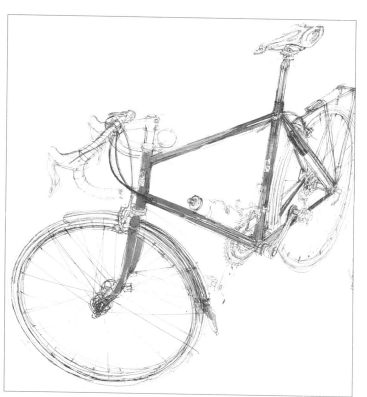

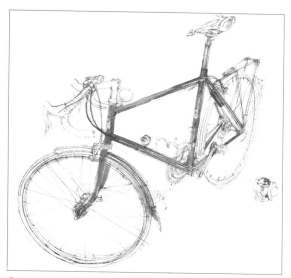

9 At what stage you add color or tone is a matter of personal choice. You can choose to leave the ink washes until now, even though some linear work remains to be completed.

10 Make some indication of the wheel rims and tires. The spoked wheel appears quite airy and insubstantial, so a suggestion of some of the spokes is probably enough in a free drawing. Add the mudguard stays, luggage rack and other details

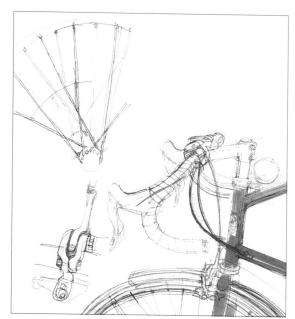

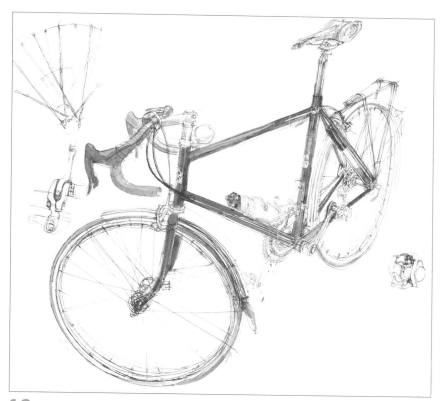

11 For any detail that is interesting but rather too small to draw in situ, make a more closely observed sketch alongside the main drawing, such as the pedal. I also made a little drawing to remind me how the spokes are arranged.

12 Finally, add some more tone and color to the frame, handlebars, seat and so on. The pale yellow helps to differentiate the tires from the rims, and the bright yellow of the water bottle gives a nice accent.

View Through a Window

Drawing a view from inside presents the viewer with a double framing, first that formed by the confines of the picture, and then within that, the one made by the edges of the window or the door.

SEE ALSO:

• Vanishing points, page 28

• Leading the eye page 40

• Contre-jour, page 52

PRACTICING YOUR SKILLS

When you first look at the scene, you will automatically choose whether to look at a window and its edges or to direct your gaze out to focus on the view beyond. There is a real need to change the focus of your eyes when you shift your attention from the aperture itself to the exterior world beyond—we never see both in sharp focus at the same time. You can make everything, inside and out, equally sharp and in focus, but you still need to direct the viewer's attention principally to one or the other. It is likely that you will tend to draw the view too large for the aperture and its surroundings—to avoid this, measure and cross-reference the view and the aperture as you draw.

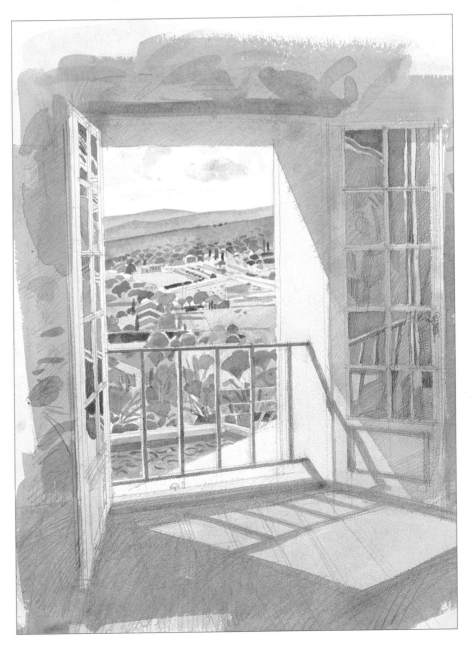

Materials

4B and B pencils

Large rule

Rough watercolor paper (stretched)

Fixative

Medium and small squirrel-hair
 brushes

Clean water

Watercolors: Vermilion, Raw
 Sienna, Gamboge, Lemon
 Yellow, Viridian, Cerulean Blue,
 Prussian Blue, Ultramarine Blue,
 Raw Umber, Indigo, Lamp Black

1 Use a rule for the initial 4B pencil drawing of the window aperture and railings. If you feel that the resulting line is too mechanical, you can overdraw it in freehand later. Plot some basic elements of the exterior scene.

2 Add the glazing bars of the right-hand window using the pencil and rule. Because this window is viewed nearly flat-on, the perspective distortion on the parallel horizontal bars is very subtle, and their vanishing point is a long way beyond the confines of the drawing's edge. Draw in freehand the distorted reflections on the uneven glass.

3 Use the railings as a drawing grid to plot the basic elements of the window-framed landscape.

4 Working across and up, add more key landscape details. Apply pencil tone to some of the areas of solids within the landscape, and shade the shadowed edges of the railings. When drawing the trees and undergrowth in the middle ground, look for and emulate their abstract shapes, ignoring any fine, unnecessary detail.

5 Using the B pencil, add the farther, finer details of the landscape. This is lit contre-jour, throwing the fronts of trees and buildings in the landscape into shadow. Add these lighter areas of decorative, semi-abstract tone with the lighter pencil.

6 Using the rule and the B pencil, draw the left-hand window frame. Because this projects out of the picture plane, the perspective of its structure and glazing bars is highly distorted. Use the vanishing point to plot the perspective of the window, and add the reflections seen in it.

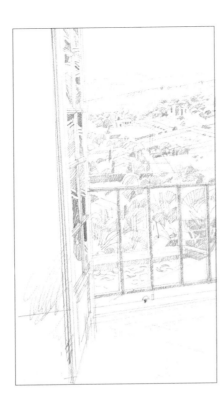

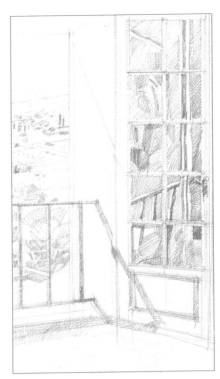

7 Tone in the reflections in the right-hand window. Use the softer and blacker 4B pencil to strengthen the darker tones in both windows and railings, then add tone to the cast shadow of the railings on the floor and window.

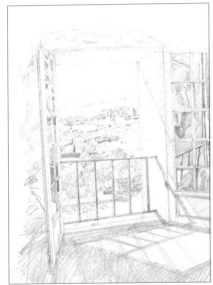

8 Use the harder B pencil for the larger areas of shadow tone on the window frame, walls and floor—allow the crosshatching to be free and spontaneous. Add the simple pattern of the terra-cotta floor in line, and draw over the shadow tone. Apply a light coat of fixative to the whole drawing.

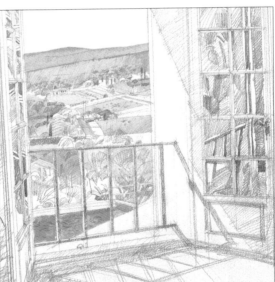

9 Starting with the lightest areas, lay down pale washes of Lemon Yellow and Yellow with a little Viridian in the landscape area, then repeat with bluer-green and a mid-green, and quickly add flat washes over the landscape. Use a Cerulean Blue over the water in the pool. Work across the whole of the landscape, moving about so that wet areas do not run into each other, and leaving the brightly-lit roofs of the buildings as white paper. Using a very dilute mix of Prussian Blue and Lamp Black, add the distant mountains.

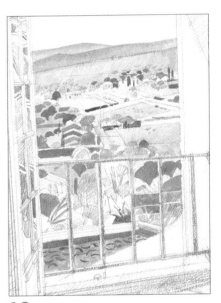

10 As soon as the first wash areas are dry, add other light colors, such as the pale pink roofs using a light wash of Vermilion. Apply darker tones on the contre-jour tree shadow shapes with fluid washes of Viridian mixed with a little Prussian Blue. Add a farther mountain edge with a thin wash of Vermilion and Prussian Blue.

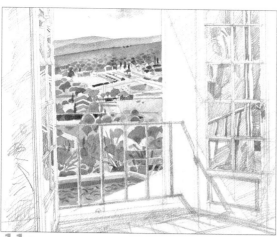

11 Darken the wooded hill, color in all other blank spaces in the foreground, and freely indicate the clouds in the sky with a very light mix of Ultramarine. Apply more washes to the internal picture frame of the French windows.

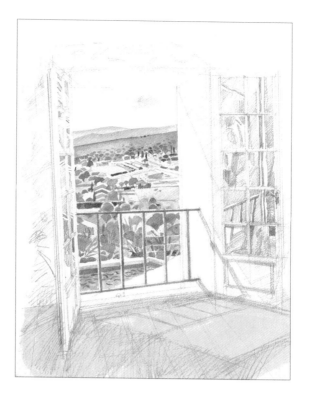

12 Lay a wash of pale Burnt Sienna on the tiled floor, and with a pale straw color made from a dilute mix of Raw Umber and Gamboge, color over the walls and doors.

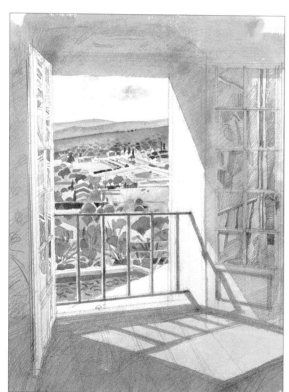

13 Add various shades of green for the reflections of the landscape in the left-hand door. Add shades of blue-gray, made from Indigo and Black and green-gray using Viridian and Black, for those in the right–hand door. Add free brushstrokes of the blue-gray to suggest the texture of the painted stone wall.

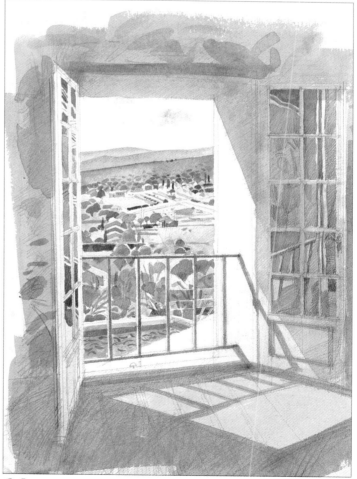

14 Finally, using the 4B pencil, strengthen the shaded areas of the walls and floor, and reinforce the pattern of the floor tiles.

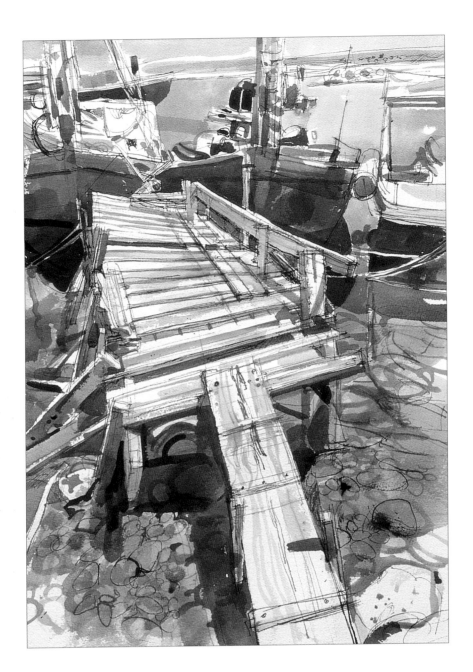

Boats and Jetty

Landing stages, pontoons, gangplanks and their associated ropes and partially submerged supports combine with mooring lines, masts and rigging to make patterns that can be seen nowhere else.

SEE ALSO:

• Vanishing points,
 page 28

• Model boat,
 page 36

• Stones and rocks,
 page 56

The myriad ramshackle features of this gangplank—the changing directions of the cross planks, the seeming randomness of the strengthening additions and bracing props, the underwater rounded rocks, the dark reflections of the boat's hulls, the tracery of rigging—all contributed to the fascinating interplay of contrasting colors and forms.

Boat-repair yards often provide richness of pattern and color, as do ports where fish are landed. Just open your eyes to the pattern, and you will find it in places that may initially seem to be unlikely. Even in a marina full of expensive yachts moored up to impeccable pontoons, by half-closing your eyes and isolating areas, there are always patterns.

Materials

Steel-nib dip pen
Waterproof inks:
 Raw Sienna, Yellow,
 Orange, Sepia,
 Bright Green, Carmine,
 Ultramarine Blue,
 Black
Nos 1 and 3 sable
 brushes
90lb (100gsm) cold-
 press watercolor
 paper
Scrap paper
Mixing trays
Clean water
White palette

1 Using slightly dilute Sepia, Black and Raw Sienna, make tentative pen lines to establish the positioning and dimensions of the shapes. Block in the main shapes using a brush, making the washes strong enough to give a key to where you are.

2 Draw in the lines that define each plank, making sure you get the relationship between the planks, posts and rails right. Lightly sketch in the outer shapes—the stones in the foreground and the boats in the distance.

3 Add further dilute washes of Yellow, Orange and Ultramarine to the foreground, lightly sketch the shapes of the larger submerged stones.

Inset: If you are sure about the composition, strengthen the first washes with slightly darker ones, being careful not to go too dark.

Taking Stock

Stand back regularly to compare your drawing with the scene, and be prepared to make adjustments. Here, I altered the position of the right-hand plank on the jetty.

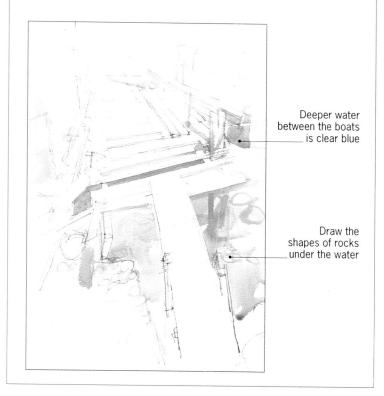

Deeper water between the boats is clear blue

Draw the shapes of rocks under the water

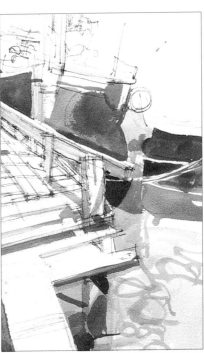

4 Make up stronger washes to go over your first foreground ones. Use a No. 1 sable brush to draw the relatively dark outlines of the negative shapes of the mooring ropes on the right-hand side.

5 Still working out from the center, use dark washes of a mix of Ultramarine, Black and a little Carmine to define the left-hand hull, then use the pen to find the patterns and lines above it.

6 Move to the right-hand boat and sketch in the positions of the vertical lines and winding gear, then define the upright struts at the top of the jetty in black. Use further washes to shape the planks on the left of the jetty.

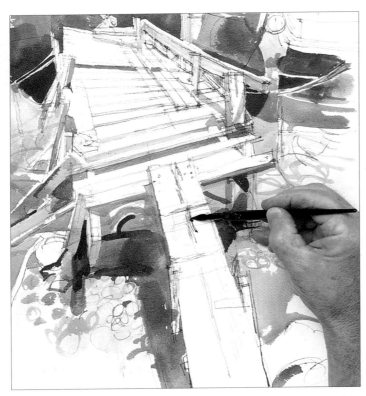

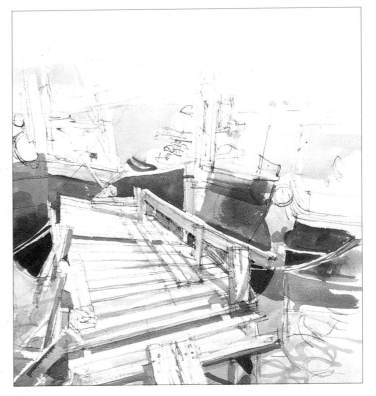

7 With Black and a little Sepia start to add some foreground details, setting the shapes of some of the stones and marking along the meeting edges of the two gangplanks—this should also show that the planks are worn, so don't make the lines too sharp or straight.

8 Use a pale Ultramarine wash to block in the area of sea beyond the boats, the far coastline, and (very faintly) the sky.

Taking Stock

The drawing is now nearing its final stages, and you can continue to refine what you have already done, strengthening tones with more washes. Because only subtle adjustments are needed, you should mix these washes on a white palette rather than on the paper—this way you can be sure of getting exactly the tone you want before you actually apply it.

Treat above-deck details as abstract shapes

Check for small areas, such as this one, that jump out too much

These underwater pebbles are too bright

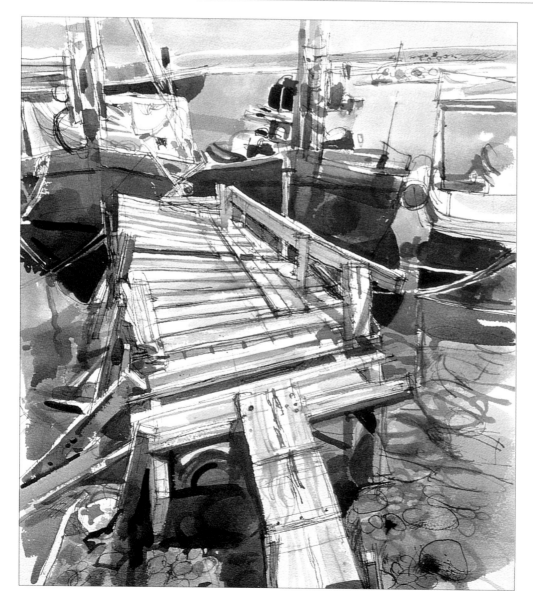

9 Make a few finishing touches—sweeping marks to define the shapes of the stones on either side of the gangplank, pen strokes on the planks themselves. Add further washes to the desired final density using all the colors including the Bright Green.

Ship in Dock

Man-made landscapes, especially those that include older industrial buildings and paraphernalia, can make fascinating subjects. This drawing, with its tangle of cranes, dockside buildings, boats and the distant landscape, looks complex, but with a little analysis, it need not present too many problems.

SEE ALSO:

• Vanishing points, page 28

• Model boat, page 36

• Using color, page 42

This project is basically an exercise in one-point perspective. The vanishing point on which all the main features converge can be easily discovered, and by working it out in an orderly fashion, always watching for vertical and horizontal correlations, you should have fewer problems with it than with some simpler and more subtle subjects. The cranes may look daunting, but they become less so if you

try to comprehend how they are put together, in a sense to build them up yourself as if they were made using a child's construction toy.

Look for symmetries and shapes, just as in the chair exercises (page 14), but even more so. For a detailed pencil drawing, I prefer to use the same grade of pencil throughout, achieving blacker and stronger lines by increasing pressure as the drawing proceeds.

Materials

B pencil
Squirrel-hair brush
Rough surface watercolor paper
Clean water
Watercolors: Cadmium Red, Vermilion,
 Cadmium Orange, Gamboge,
 Raw Sienna, Indian Red, Viridian,
 Cerulean Blue, Prussian Blue,
 Ultramarine, Lamp Black

1 Establish the basic elements—the right-hand edge of the dockside and the left-hand edge of the crane's tracks. Both are nearly vertical and will meet at a vanishing point on the far shoreline. Draw in a line for the shore, then establish some simple details for the main boat-edges and some vertical derricks on the deck. Sketch more of the main elements, the distant hills and the main dockside sheds.

2 Quickly move into drawing in detail, in this case the large crane in the foreground. Don't be put off by its apparent complexity—close examination reveals that it has a basic, regular geometric structure.

3 Continue to draw the tracery of the crane's structure. Draw the control cabin of the foreground crane in line with the base and therefore with the same vanishing point.

4 As you move the drawing from the foreground crane to the one behind it and over to the crane booms on the ship itself, keep checking the shapes left between the various components.

5 Because this drawing is mainly a preparation and guide for color application, there is no need to apply all the dark tones—though it is sometimes helpful to use little areas of shading to indicate where you will need to place the darker colors later.

6 The bottom of the dry dock is strongly marked by areas of discoloration. Indicate some of these in pencil, but leave most to be rendered in color. Mark the far shoreline positively. Draw in some pencil guidance for the clouds, but make sure that the marks are very delicate.

7 When deciding which color washes to apply first, look for light or bright areas that are unobstructed by other shapes cutting across them. Both dock-side cranes and the booms on the ship are bright yellow—use the Gamboge for this and to put in any other small features while it is on the brush.

8 Where the complicated structure of the cranes is light-colored against a darker background, put a pale gray wash made from diluted Black over the whole area, leaving the detail definition until a later application of the back-ground. Apply the only other bright color, the red on the ship's hull, with a wash of Cadmium.

Taking Stock

Freely apply some indication of the main colors of the interior of the dry dock and of the dockside. Remember that this is a drawing—not every inch needs to be covered with color.

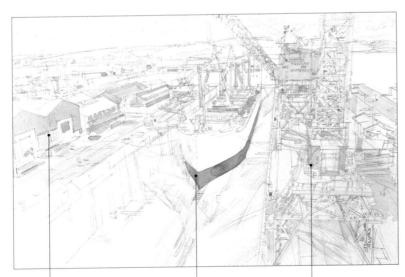

Wash in similar but separated colors at the same time

Wash in the red antifouling even where it is in shadow

Put in all the bright yellow areas at the same time

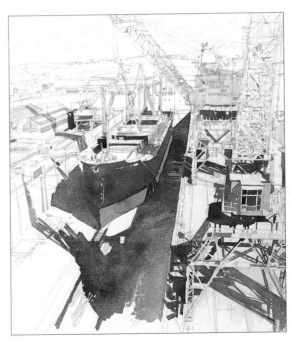

9 From now on the order of applying washes is not really critical—I chose to put in most of the strong cast shadows at this stage, in order to establish the darkest tones. For this I used a wash of Black to which a little Vermilion and Prussian Blue had been added.

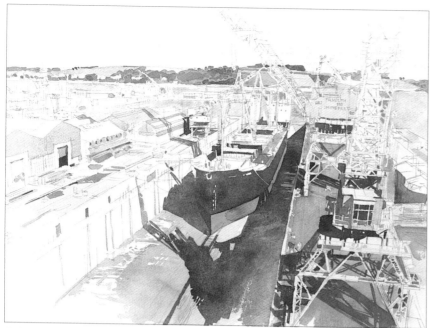

10 Using mixes of Viridian, Gamboge and Cerulean Blue, apply washes on the far shore and the sea. Using warmer tinits of Raw Sienna, Cadmium Orange and Indian Red, add washes to the floor of the dry dock and the right-hand dock—all of them background colors to the cranes and ship.

11 Complete the background with the cloudy sky, to give a strong band of color and texture on which to hang the rest of the drawing. Use varying but light shades of Prussian Blue and Ultramarine for this.

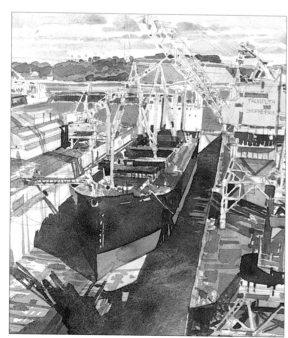

12 Apply darker tones of brown and black on the ship's deck and the left-hand dockside, which help to accent the yellow booms and enhance the impression of crosslight. Drawing freely with the brush, add detail and accents to the cranes, buildings and surfaces.

13 Add the finishing touches—slight strengthening here, small additions of tone or color there, one or two extra pencil lines—not to cover every inch of paper surface, but to make the drawing hang together as a whole.

Gorge and River

Here is an opportunity to utilize your observations of moving water and reflections while placing them in a variously featured landscape ranging from tree-covered hills to bare rock.

CROSS-REFERENCES

SEE ALSO:

• Vanishing points, page 28

• Using color, page 42

• Water, page 69

The river Gardon in the south of France flows under the famous aqueduct, the Pont du Gard, eventually to join the Rhône and the Mediterranean sea. In the view chosen for this project it is in gentle summer mode, sometimes turbulent and cascading, at other times appearing to be still as a pond, and overall not noticeably constrained by the cliffs of the surrounding gorge.

In winter, however, the river becomes swollen by snow melt, and when it reaches the gorge it is squeezed to become a raging torrent. Each summer the evidence of this astonishing violence can be judged by the height of the debris in the bordering trees. Huge rocks are sometimes shifted, and shoals appear and disappear to form the year's pattern of shallow rapids and deeper pools of slow-moving water.

I mention all this to remind you of another function of drawing—that of recording change both in the aspect of a subject, and also in your response to it. Because you have drawn a subject once, it should not deter you from revisiting it again and again. Even if there are no obvious physical changes, different lighting conditions can greatly alter its appearance; moreover, on subsequent visits to the location you may find yourself responding quite differently, to the extent of noticing aspects of the subject that you missed the last time that you drew it.

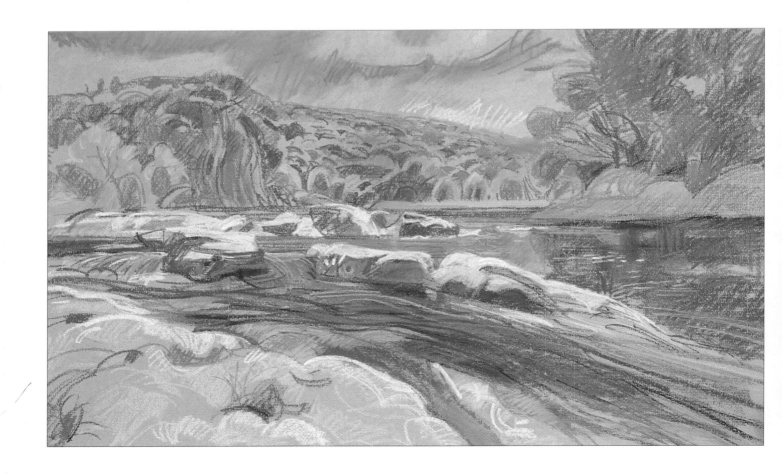

Materials

Green-gray Ingres pastel paper

Clean water

Soft pastels: Lemon Yellow Tint 0,
 Lemon Yellow Tint 6, Naples Yellow
 Tint 6, Viridian Tint 1, Grass Green
 Tint 4, Terre Verte Tint 5, Sap Green
 Tint 8, Cool Gray Tint 1, Cool Gray
 Tint 6, Ultramarine Tint 3, Prussian
 Blue Tint 1, Indigo Tint 3, Indigo Tint 8

Fixative

1 Because this river view is dominated by the color green, work primarily with the range of yellows and greens in the materials list, Cool Gray Tint 1, Cool Gray Tint 6, Ultramarine Tint 3, Prussian Blue Tint 1, and Indigo Tint 3 and Tint 8. Indicate the main elements of the composition using bold strokes of the appropriate colors.

2 Starting from the middle of the composition, establish the relative positions of the two groups of midstream rocks, using Cool Gray Tint 6 to outline the change from light to shade. The vertical faces of rocks, cliff and trees present their shadow side to the viewer, only receiving sunlight on their top sides.

3 Continue to work outward, bringing out the specific shape of each rock. To find a base color that is not the color of the paper, I filled the sky area with a mix of Ultramarine Tint 3 and Cool Gray Tint 1, rubbed together a little. With Sap Green Tint 4 establish the bright halo around some of the lightest trees.

4 Now put in the characteristic, fan-like shadow shapes on the tree-covered hill with mixtures of Indigo Tint 3 and Sap Green Tint 8, leaving much of the paper color untouched. Make these shapes smaller as they near the top, to show the curvature of the hillside.

5 Indicate the trunks and branches of the trees on the right-hand bank of the river with Indigo Tint 8 and Cool Gray Tint 6 pastels. Use the same colors, plus Sap Green Tint 8 and a little Viridian Tint 1, to make a crosshatched tone for the reflections of these trees in the slow-moving water on the same side of the river.

6 Apply vigorous strokes of Indigo Tint 8 and Cool Gray Tint 6 over blues and greens, rubbed together with some Naples Yellow Tint 6, to give an impression of the faster-moving water in the foreground.

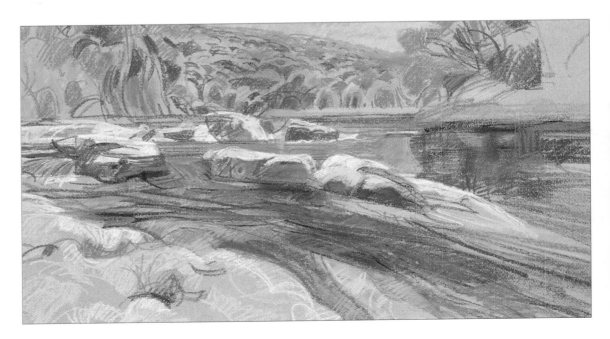

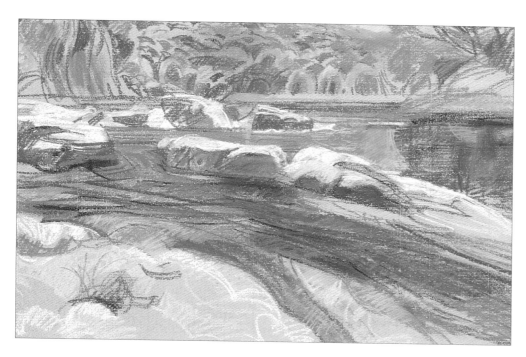

7 To give more emphasis to the rocks in the foreground, and also to give some deeper tones in the foreground water, use Indigo Tint 8. Describe the convolutions of the water-worn rock in the foreground with the two lightest colors, Lemon Yellow Tint 0 and Cool Gray Tint 1. Give emphasis to plant growth in the hollows.

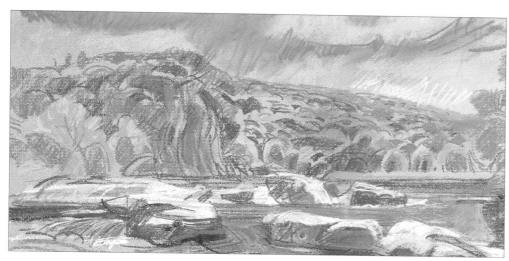

8 Work into the sky with Prussian Blue Tint 1, and apply a little Lemon Yellow Tint 0 at the horizon. Give the trees at the left of the cliff more contrast using Lemon Yellow Tint 6.

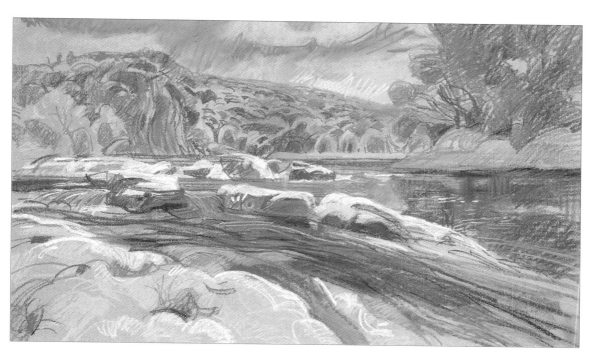

9 Complete the block of trees at the right, and add points of light with Lemon Yellow Tint 0 on their reflections in the dark water beneath them. Reinforce the light accents on the mid-stream rocks, and add a few more strokes of Indigo Tint 8 to the fast-flowing water in the foreground. Use fixative to protect.

Sea and Cliffs

Where the sea meets the shore at a cliff face, patterns abound. The cutting action of the waves will have revealed the layers of rock laid down over millennia, and the waves have constantly moving patterns.

SEE ALSO:

• Sharp edges with tone, page 24

• Vanishing points, page 28

• Leading the eye, page 40

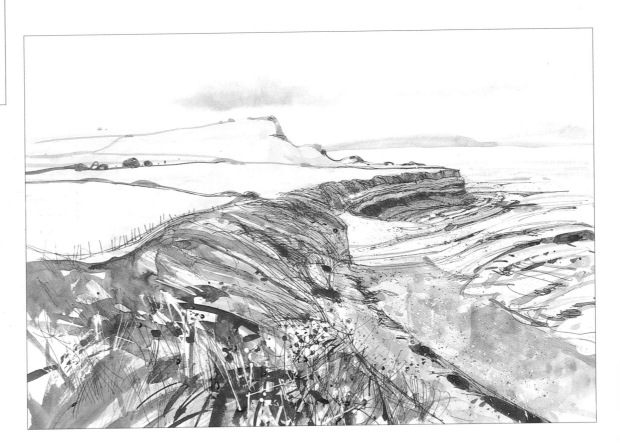

The fascination of cliffs at the seashore is the way that evidence of the underlying forces that provoke continents to shift and to fold into mountains when they collide, normally hidden under benign topsoil, is revealed in all its tortured and twisted splendor.

Sometimes, as here, the strata continues onto the beach, the uptilted layers making strongly defined patterns similar to those on the cliff face. I am struck by the contrast between the soft rounded forms of the land mass and the hard underlying structure, laid bare as though by a surgeon's knife.

Of course, not all cliffs are like this—strata may not be so obviously visible, or may be so broken up that no pattern can be descried. But even if sedimented layers cannot be identified, pattern is what you must seek. Seemingly randomly fractured rock, if closely examined, always shows some inner logic, some shapes that appear more often than others, distinguishing it from other patterns.

Bring out these patterns, and exaggerate them if you like—let the energy of your line underline the contrasts that you see. Waves that, together with wind and rain erosion, render all these rock strata visible also have their own logic. Of course they are never still, and drawing them from direct observation would seem to be rather problematic. Photography can freeze the action, but I would rather sit and watch for a while, and gain an understanding of the constantly repeating patterns.

Materials

Steel-nib dip pen
Drawing paper (stretched)
Clean water
India ink
Medium watercolor brush
Bamboo pen
Masking fluid
Rag
Painter's tape
Old toothbrush
Permanent white gouache

1 With the pen and dilute India ink, start to draw the scene directly, using broad sweeps of pen strokes. Use darker, dotted lines tentatively to plot the main areas of the composition.

2 Use the brush briskly to lay down washes of pale, dilute ink that establish the main tonal areas. Returning to the pen, draw in the layers of strata on the cliff face, mixing very little water with the ink. For the top of the cliff, where the vegetation meets the cliff edge, use slightly more water with the ink, to vary the line and more closely approximate the tone of the undergrowth.

3 I now felt free to begin the complex, linear patterns of the grasses in the foreground, and the pebble detail on the beach, with the bamboo pen and masking fluid—the drawn lines read as light against darker washes that will be overlaid later. Allow the masking fluid to dry, then lay down the initial tone work with the brush and differing dilutions of ink, using free calligraphic strokes.

4 Returning to the steel-nib dip pen, I drew in the layers of strata on the cliff face. The ink was still diluted, but with very little water mixed in, leaving it quite dark. For the top of the cliff, however, where the vegetation met the cliff edge, I used slightly more water with the ink to vary the line and more closely approximate the tone of the undergrowth. Carefully check that both masking fluid and washes are thoroughly dry, then remove the fluid by rubbing gently with finger and thumb, revealing the negative line work beneath.

5 Mask off the sky area with a rag held in place with a little painter's tape, then lay down some fine spattering using an old toothbrush dipped in dilute ink, spraying it on to the drawing by rubbing a fingernail along its bristles. Make larger spattering patterns by loading the watercolor brush with ink and tapping it gently against the toothbrush, held 3–4″ (75–100mm) over the drawing in your other hand.

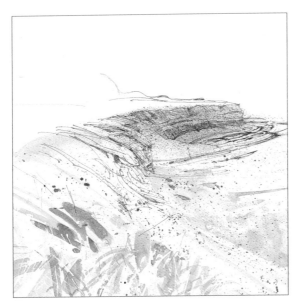

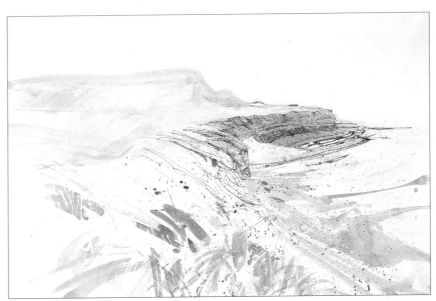

6 Reverting to the steel-nib dip pen, and working with pure black ink, draw into the gray tone made with fine spattering on the cliff face in the middle ground, then develop the drawing of the shape of the cliff edge above this.

7 Using white gouache, work into the drawing to define the areas of high fields and cliffs on the center left of the drawing. Draw into the fine gray spattering area in the middle ground, and add some white spattering in the foreground to give variety to the textural qualities.

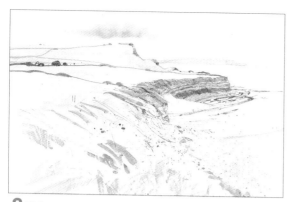

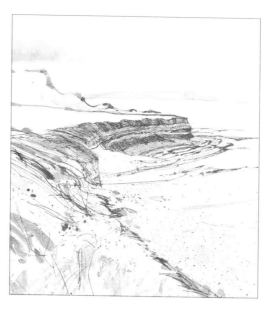

9 Use the steel-nib dip pen to add black line work to the beach, cliff face and foreground, occasionally softening some of the broader strokes with a finger. Vary the pressure on the nib to give variety to the marks.

8 Using very dilute ink, add cloud and sky effects with the brush, and use a less dilute mix for the coastline on the horizon. Apply further tone to the cliff face from the middle ground through to the foreground, and add the hedges and bushes along the field edges.

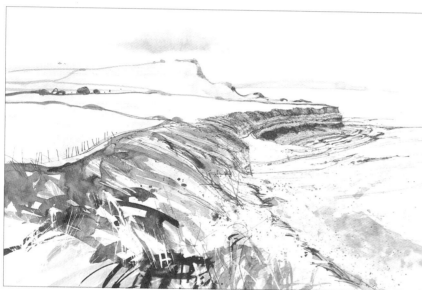

10 Lay down the second application of masking fluid over the foreground, beach and sea. When this is dry, work over the masking fluid with broad, dark brush-strokes, contrasting visually with the finer pen work in the middle ground, as well as giving an impression of depth. Make sure the drawing is completely dry before carefully removing the masking fluid.

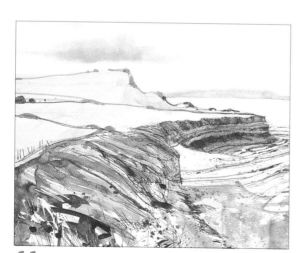

11 Using both ink washes and white gouache with a little ink to give a light gray tone, work over the the cliff faces to define the strata and re-emphasize some of the cliff structure.

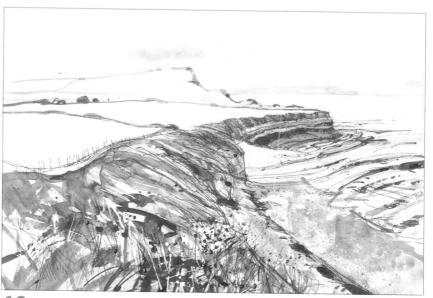

12 Using the steel-nib dip pen and black ink, finally add some linear detail, both to the vegetation in the foreground and the sea itself.

House Façade

An architectural façade has by definition very little depth, so the interest must chiefly be centered in the pattern it presents.

SEE ALSO:

• Sharp edges in line,
 page 20

• Strong, direct light,
 page 44

• Stones and rocks,
 page 56

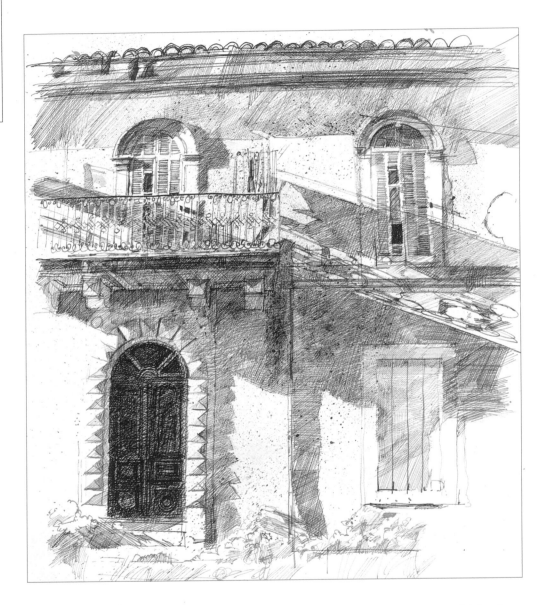

For this subject, you need to choose a façade with interesting architectural features. I was particularly intrigued by the form-revealing shadows cast by the decorative balcony and arched windows of this old house in France.

Shadows like those in this view appear only briefly, when the sun is on the verge of throwing the façade into complete shade. This makes the scene almost impossible to capture *in situ*, especially if you are using a fairly slow process, such as pen and ink hatching. So I used a photograph that "froze" the shadow at a moment when the shadows were at their longest and most dramatic.

There are many other ways to tackle such a subject—this is intended solely as an opportunity to show the tonality and richness of texture that can be achieved by fine crosshatching aided by a little dotting and spattering.

Materials

Steel-nib dip pen
Hot-press watercolor
 paper
Clean water
Inks:
 Black, Ultramarine,
 Viridian, Yellow
Old toothbrush
Blade (optional)
Permanent white
 gouache (optional)

1 Using a dilute solution of Black, plot the basic elements of the composition with a fine line and dot, thus making a framework for more detailed drawing later. Dilute the ink by alternating the pen between ink and then water—this enables you to vary the tone as you draw.

2 Extend the framework, working over the whole image, and drawing in the elements of the architectural structure. Ignore the shadows at this stage.

3 Draw the fine tracery of the metalwork on the railings of the first-floor balcony, looking for the essential characteristic of the repeat pattern in the metalwork. Begin drawing the fine detail in the shutters behind the balcony's railings.

4 Begin to establish some of the shadow areas by hatching with a dilute mix of Ultramarine to represent the cool tones, define the shadow edge with a pale outline.

5 Use very dense crosshatching to create the dark tone of the doorway. Note how previously drawn details of the door show through even when so many lines have been drawn over them.

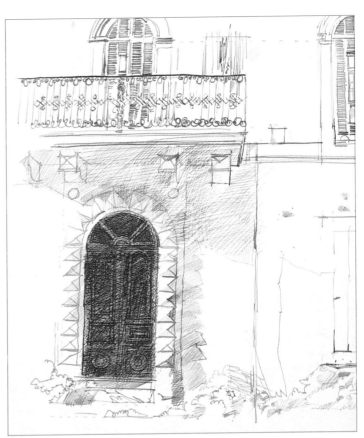

6 To build up the crosshatched areas, turn the drawing in different directions so that your hand and wrist aren't forced into awkward positions. Use a mix of Ultramarine and Black hatching, and strengthen detail by drawing back into the image with full-strength Black. Reinforce the detail with hatching.

7 Use dilute Ultramarine ink to add shadow detail to the faceted pyramidical stonework around the door. Work across these shadow areas, and increase the length of hatched strokes as the area becomes bigger. Using varying mixtures of the Viridian and Yellow, work into the grass at the base. Use the Ultramarine to define the edge of the cast shadow as it skims across the lower, right-hand window.

8 Define the outline of the shadow areas across the top of the image with a pale, dilute mix of Ultramarine and Black. As each shadow area is built up, reinforce the detail with Black. Draw the roofline.

Taking Stock

The overall image now begins to take shape properly as you build up further shadow areas and add detail.

Freely draw the wrought-iron balcony with Black lines

Combine Ultramarine and Black cross-hatching with some finger-printing and spattering to produce a rich texture

The panel moldings show through, even though overlaid by solid hatching

9 While not the quickest way of rendering the pattern of cast shadow, the gradual tonality resulting from fine crosshatching has a uniquely rich quality.

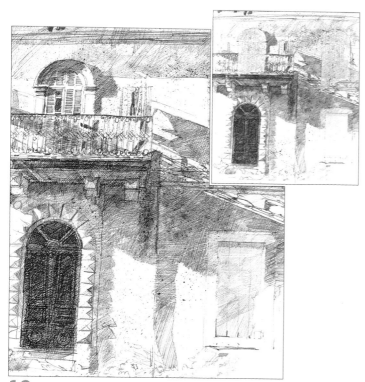

10 Represent the interesting textures on the façade by spattering a range of inks from an old toothbrush.

Inset: Mask off the areas where you don't want any texture to go, using low-tack painter's tape.

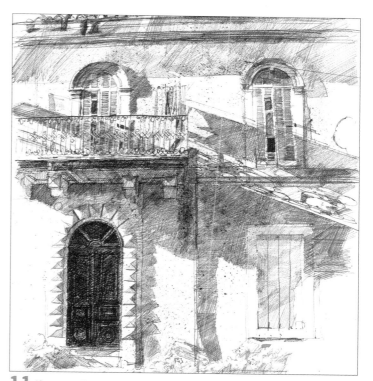

11 If sprayed texture is too dominant, reduce it with white gouache, by scratching back with a blade or even remove and replace any passage which has become too dark (see pages 150–1). To finish, add a little Viridian and Yellow hatching to give some indication of the vegetation at the base of the building.

Townscape

My method for drawing this waterfront in Brisbane, Australia, was rather different from the procedures that I generally use.

The airy delicacy of the curtain glass cladding and the reflection in it of adjacent buildings were my principal interest, and I wanted first to establish these features carefully and successfully, and only then to progress to an increasingly boldly drawn foreground.

Instead of first plotting out the general composition—the usual way of working—I took the risk of visually assessing the tower's size and position in the composition, and going straight into bringing out the detailed pattern of the glass walls. You may feel confident enough on occasions to do the same. The reverse, white side of mounting board takes soft pencil marks in a pleasing way.

This composition is based on a contrast between fine details, such as those in the skyscraper, which becomes the focal point, and the bigger, abstracted areas to the right and in the main foreground. It will help, as you work from detail to broader area, to avoid sharpening the pencil, and thus allow its gradually blunted point to make broader and more vigorous marks.

Materials

4B pencil

Mounting board

1 Establish the height of the skyscraper, then draw in the architectural grid of horizontal and vertical lines fairly freely, without losing the structure's architectural feel. Start to add the strong reflection of another building illuminated in the façade of the main tower.

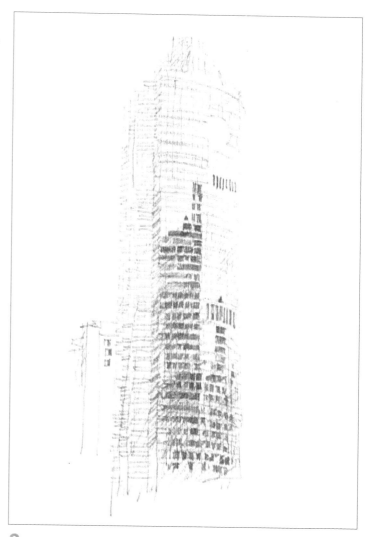

2 Continue the drawing of the distant tower, extending the vertical detailing from top to bottom, adding the horizontals over its the curved façade, and filling in the dark reflection as you progress. Draw in the details of the windows, which are individual parts of a pattern, rather than an overall texture.

3 Continue drawing the tower in detail—do not labor over this, but keep the drawing fresh and spontaneous. Add tone to the reflected area to give it local color. Leave the large sunburst reflected towards the apex of the building as a pure white globe.

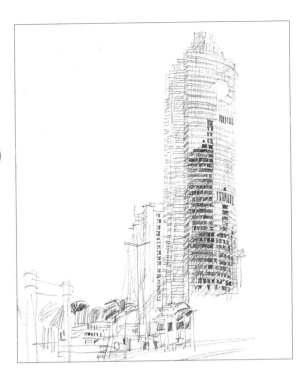

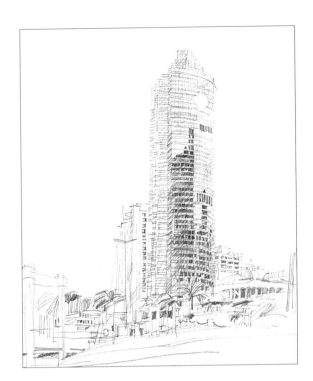

4 Now move out and allow the drawing to take in the patterns and details of other buildings, and the moored boats around the base of the building, following the general patterns.

5 Include the middle-ground detail, extending the linear patterns. Give the dark areas a variety of tone to emulate the variety of darks in the shadow areas. Work quickly to keep the vitality of the drawing.

Taking stock

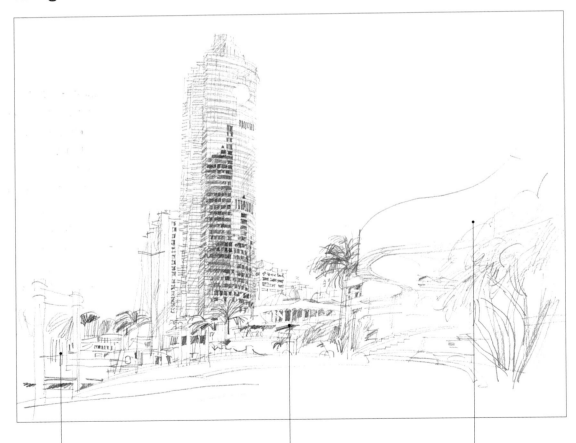

Now draw the trees and bushes in the near middle ground, keeping them loose and free in common with the rest of the drawing. Add the larger trees beneath this, emulating their basic pattern and shapes without drawing in foliage in a meticulous way.

Keep the drawing quite sketchy here

Add the rounded shapes quickly

Put down the broad outline of the trees, and add the canopy

6 Draw in the broad sweep of the canopy coming almost out of the picture, and add its light shadow tone. As the drawing broadens out, your marks can become increasingly freer.

7 Draw in any close foreground features that you wish to show to give context to the drawing, such as the canopy. Then stand back to check, and give the drawing a final, overall assessment to check the strengths of the tonal areas, and strengthen them where needed.

Interior Sitting Room

As we have already seen on page 29, parallel, straight-sided objects and the walls containing them in an interior view, converge on vanishing points, just as they do in outdoor subjects.

SEE ALSO:

• Chairs,
 page 14

• Vanishing points,
 page 28

• Contre-jour,
 page 52

In this sitting room the tables, carpets, sofas and easy chair are all aligned parallel to each other, making it easy to deduce a common vanishing point. Even if the furniture and carpets are more randomly arranged, the fact that they all sit on the same ground plane (the floor), and generally have horizontal surfaces, means that they will all be on the same horizon, even though their vanishing points may not be shared. You may feel by now that it is not necessary actually to mark the vanishing points—a quick projection by eye, together with other cross-checking being enough to establish each element.

Many artists bend perspective by tipping the ground plane toward the viewer, and you should consider this option if it improves the impact. The intention here is to create an impressionistic view, adding some washes of color and tone to suggest the ambient light.

Materials

Graphite stick

Drawing paper

Rough watercolor paper
 (stretched)

Steel-nib dip pen

Clean water

Waterproof inks:
 Yellow, Orange,
 Raw Sienna, Pale
 Blue, Ultramarine,
 Viridian, Sepia,
 Scarlet, Carmine,
 Black

Brushes:
 medium squirrel-hair,
 No. 2 sable

Scrap paper

1 Begin by making some preliminary studies to determine the desired composition, using a graphite stick to render a wide range of tones quickly. Don't be afraid to move objects around and alter the scene while doing these initial studies.

2 Having chosen the eventual composition, draw in two diagonals from corner to corner to help assess the positions of the objects within the picture. Referring to this—but drawing from reality—plot the positions of the main elements of the composition, using a dilute mixture of inks, such as Raw Sienna, Sepia and Black that relate to the colors of the objects themselves.

3 Starting from the candle on the farthest coffee table, begin the preliminary drawing of the elements on both sides to determine the width of the drawing. Use undiluted Pale Blue and Carmine, but continue to dilute the darker ones, especially Black. Establish some of the major verticals around the central features.

4 Use crosshatching in Ultramarine and Raw Sienna to render some initial tonal areas. Measure the wall clock with outstretched arm and pen, and plot its position and proportion, then make a quick statement of the broad arc of the hanging lampshade. Keep the lighter areas of the composition pale, so that they can be corrected later if needed. When drawing foreshortened items, such as the right-hand coffee table, check the positions of its near corners vertically with the details above.

5 Start the reflections on the surface of the coffee table, and establish the large house plant against the window, using Viridian ink modified with a little Yellow. With a dilute Black mix draw further vertical details, such as the window shutters, and render light crosshatching over the wall space between the windows, to help judge the tonal elements of the composition. As the drawing progresses, make more confident, darker pen marks.

6 Using the Sepia ink establish some of the major details of the left-hand elements. As the drawing advances into the foreground, strengthen the pen marks to imply recession to the lighter distant items. When adding patterned detail, such as that on the carpet, analyze it geometrically, and assess how it is altered by perspective before starting to draw.

7 Add the first wash to the dark wall area within the drawing, using the medium squirrel-hair brush and a slightly dilute mix of Viridian and Ultramarine. Apply a darker and bluer wash tone to the shadow areas of the upholstery on the chair beneath the clock. Repeat this for the chair on the left, with a dilute mix of Scarlet and Ultramarine, using the scrap paper to test the mixes beforehand. Add a thin wash of mixed Orange and Sepia to the warm shadow areas on the walls.

8 Use the pen to introduce more details, such as the molding on the right-hand shutter, and the clock face. Add basic color washes to the fabrics on the sofas using diluted mixes of Carmine, Pale Blue and Sepia.

Taking Stock

Run a very free, pale wash over the floor and shutters, and add foreground details with the pen, using bold strokes. Give the back wall an overall wash.

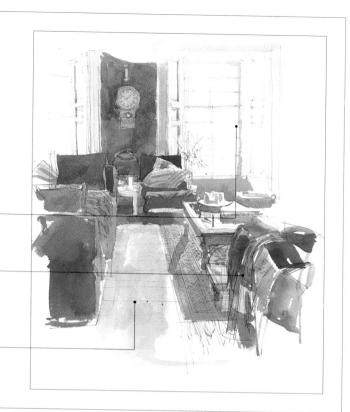

The windows become brighter as the interior nears completion

Add suggestions of the pattern on the throw with free pen marks

Add a darker tone to the floor, using a dilute wash of Raw Sienna. Leave reflected areas to shine through

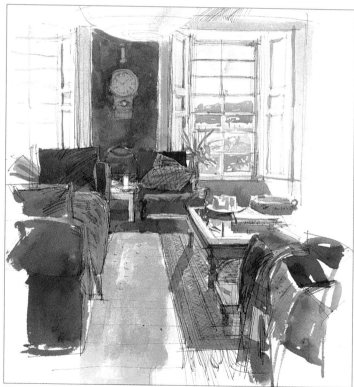

9 Being careful not to destroy the brightly lit feel of the windows, add a little exterior detail, using the No. 2 sable brush and very dilute mixes of Viridian, Yellow and Sepia. Note the counter-change of tone on the window bars, where a dark tone is seen against the bright sky and a light tone against the darker suggestion of landscape. Use the pen to strengthen some of the darker interior tones with Black ink.

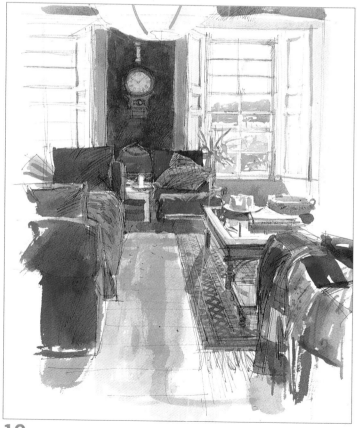

10 As a final stage, add a third, dark wash to the central wall panel. Apply broad brushwork to the ceiling and lampshade, and add final pattern to the carpet, using the No. 2 sable brush and Sepia ink.

Uphill Street

The perpective principles employed in this project constitute a small extension to those already demonstrated on page 28. It is basically single-point perspective, but involving more than one horizon line.

SEE ALSO:

• Chairs,
 page 14

• Sharp edges in line,
 page 20

• Vanishing points,
 page 28

PRACTICING YOUR SKILLS

The only new rule is that the parallel sides of an uphill street vanish to a new false horizon, higher than that to which the truly horizontal elements vanish. Imagine the street as part of a complete upward-sloping plane—this then becomes your new flat plane with this new horizon, to which all parallel lines on it, including your street, will vanish. However— and this is very important—the true horizontal floors of the buildings still vanish to the true horizon, so that where the upright buildings meet the rising ground plane there will always be a triangle of extra wall erected to make the first truly horizontal floor.

You can judge the steepness of a slope by reference to these triangles. They work the same for a downhill slope, so that from a view looking downhill, the apparent horizon and vanishing point for the street will be below the true horizon, instead of above it.

In this cross section of buildings on a hill, the red one is on the flat, but the deep yellow one has to accommodate to a steep incline, requiring a (pink) triangular infill to give a horizontal base. The next one is built on a shallower incline, so the infill triangle is flatter. The orange arrows point to the horizons and vanishing points of each gradient.

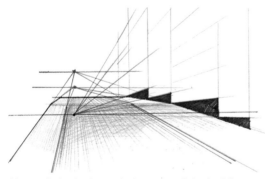

Here, all the horizontal elements of the buildings (orange lines) converge on the lowest vanishing point, showing the level of the true horizon. The steeper gradient of the road goes (blue lines) to the highest vanishing point. Where the blue street lines intersect the orange base lines and the buildings' uprights, they make purple infill triangles.

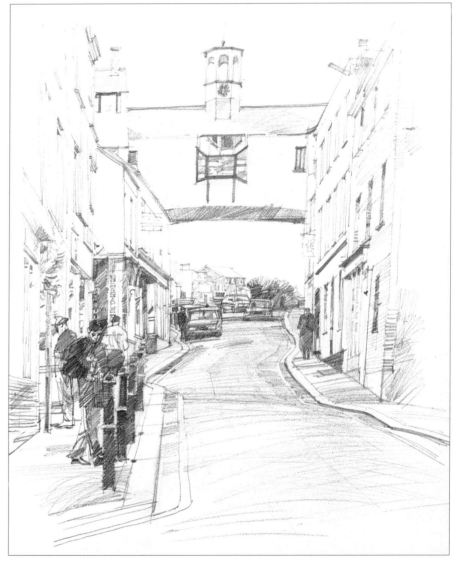

Materials

2B pencil

Cold-press watercolor paper

Soft putty eraser

1 Roughly establish the vanishing point of the buildings on the right. Draw a horizontal through this to establish their true horizon, well below the actual horizon. Because the street narrows, the buildings on the left, which are not parallel to those on the right, have a different vanishing point on this same horizon. Roughly draw this horizon in, and add perspective lines from the windows and architectural features of the buildings on both sides of the street, converging on their different vanishing points on this horizon.

3 Add some uprights to make sense of the maze of construction lines. The vanishing point of the right-hand building is highlighted with a circle, on which all the parallel horizontal features of the buildings converge. The triangle at the base of the building shows the difference between the horizontal plane of the building and the ascending road.

2 Sketch in the road markings and curbstones simply to act as contour lines that define the different levels and undulations of the road itself. Because the road is going uphill, the vanishing points for the differing levels of the road are higher than those of the buildings.

4 Repeat the process for the building on the left. This is horizontally parallel to the one on the right, with a vanishing point on the same imaginary horizon, but because it is not vertically parallel (due to the narrowing of the road), its vanishing point is on a different position on this horizon.

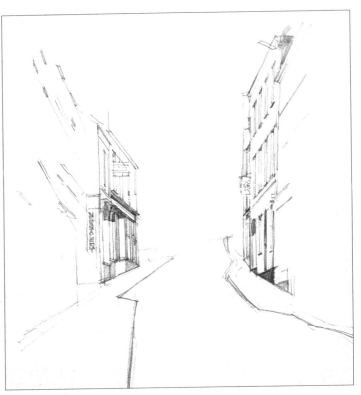

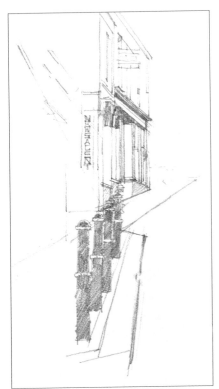

6 Add the row of bollards on the left of the road. Their tops all converge on the same vanishing point, allowing for slight undulations in the road—and, because they rise in parallel with the ascending road, they share this vanishing point with that of the road.

5 Delete most of the construction lines, allowing the uncluttered, preparatory image to emerge. Add a little more detail in line and tone, and use tone to further establish the buildings.

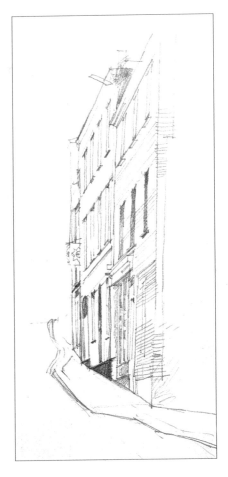

7 Add the next building on the right-hand side— its vertical plane is parallel to that of the one already drawn, so it will share a vanishing point with it. When drawing old buildings, watch out for where the features of a building do not appear to obey the rules of perspective, due to having moved over the years.

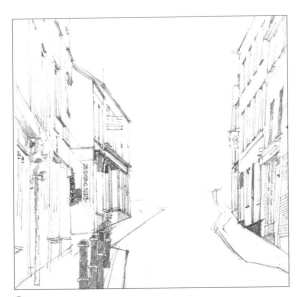

8 Draw in the nearer buildings on the left side of the road. Because these are slightly angled to each other, and their façades turn away from the viewer's eye (in descending order), their vanishing points alter slightly, but all still sit on the same, mutual horizon. As the angle of the façades becomes more acute, fore-shortening causes certain features, such as windows, to become little more than narrow slits.

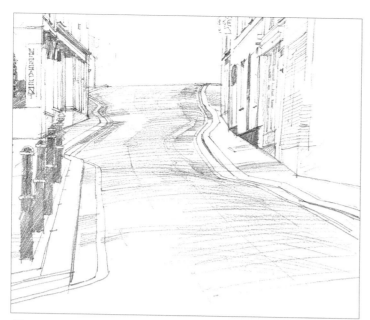

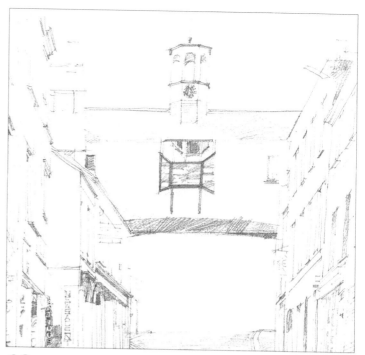

9 Now begin working on the flat planes of the road surface. The broad strips of road markings diminish in scale as they recede, but even these are distorted, their widths seemingly changed by the fluctuations in the road's surface. Allow the shading to follow and describe the camber of the road surface, noting how the tones of the different areas on the road vary, giving a broad pattern of flat areas.

10 Add the arch. Unlike the rest of the composition, which is receding away from the picture plane, this is parallel to it, so it is hardly distorted by perspective. The octagonal cupola on the roof, positioned centrally in the viewer's line of vision, is subject to one-point perspective only.

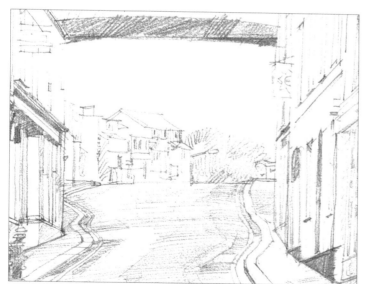

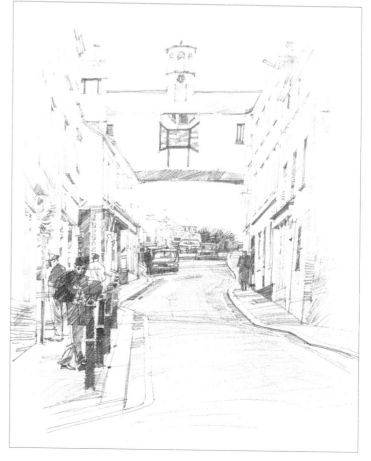

11 Draw in the distant trees and roofs of buildings beyond the brow of the hill, to give a sense of depth to the final composition.

12 Use the eraser to carefully delete the areas of drawing to be covered by transitory elements, such as people and cars—then add these elements, to bring the image to life and heighten the sense of human presence.

Standing Nude

Drawing the human figure is very demanding, not because the subject is intrinsically more difficult, but because we have a very acute sense of the "rightness" of the representation of the human.

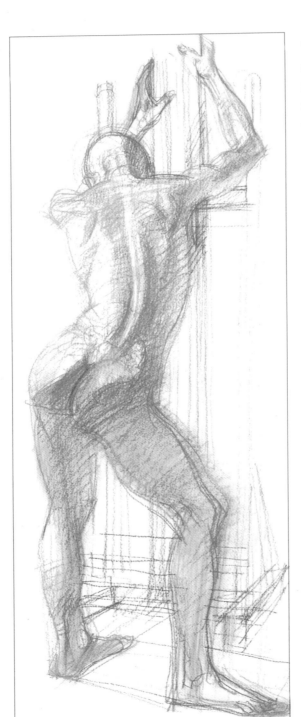

Trees, flowers and plants allow a certain amount of inaccuracy in their representation, but the slightest misrepresentation of the human figure will be spotted immediately.

However, this should not make you fearful of drawing the figure and treating it as a form like any other. Some knowledge of the underlying anatomy, the structure, can be useful, just as it is when drawing a plant or a machine, and the human figure is certainly a wonderful piece of engineering.

Humans—standing, walking, running and jumping on only two legs—have to be especially good at achieving and maintaining balance. When drawing the standing figure, the most important thing is to make the balance appear believable.

Materials

Charcoal

Drawing paper

Pastel pencils:

 Raw Sienna,

 Light Blue, Pink,

 Burnt Sienna

Small mirror

Fixative

1 Before starting the major drawing, draw a series of fast studies until you find a pose that you wish to develop, and that the sitter can sustain. Establish the main vertical line through the figure, and rub the charcoal with a finger for elementary shading. Imagine that the sitter is encased in a rectangular block of transparent material that just encloses the outer points of the pose, and lightly sketch this to form a structure that allows you to plot the main points of the figure.

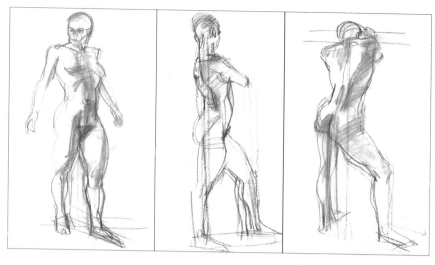

2 This pose is a version of one of the quick sketches. Using the Raw Sienna pencil, lightly sketch in the main lines of force—the curve of the spine, the pelvic tilt, the legs and the angle of the shoulders. Plot the line of the posterior superior iliac spines.

3 Working out from the center, strengthen these lines of force, and correct them if necessary. At this stage, ignore the outline edge of the figure—it is essential to establish the basic structure first.

Anatomy

Here you can see the principal places where the skeleton is close to the skin surface. In the front view the clavicles or collar bones are very clearly seen, and their angles define any shoulder tilt. Lower down, the angle of the hips is shown by the relative heights of the two pelvic bones, the iliac spines (indicated on figure shown right). The best clue to the pose from the back is the groove that follows a line of bony pro-tuberances from the deeper spine or vertebral column. Pelvic tilt is seen by reference to the inverted triangle that defines the sacrum at the base of the spine. Higher up, the two shoulder blades or scapulae each have a raised edge that usually shows as a groove pointing toward the point of the shoulder. These points of surface bone show as dimples in most individuals, but as ridges and bumps in more emaciated figures.

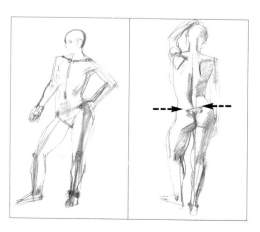

5 Using a Light Blue pencil, draw in the cooler shadow areas around the spine. Loosely sletch the warmer tones on the right leg, and establish the foot of this leg in Pink. Plot the left foot, taking care to establish the accurate relationship between the feet.

4 Develop the spine, which is fundamental to this pose. Start drawing the head and weight-bearing leg, but do not define them yet. Include some of the darker shadow areas around the buttocks.

6 Work over the drawing with the Burnt Sienna for sharper definition, correcting mistakes and sharpening existing lines. Establish the flats and troughs around the spine, and define the two "ropes" of the muscle groups on either side of the spine, taking the drawing to the outer edge of the back. Check the length of the weight-bearing leg, and draw its outer edges.

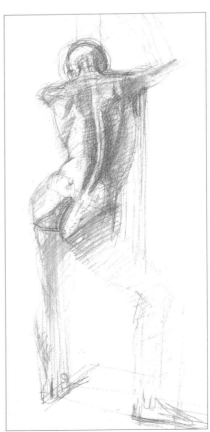

7 Bring the left-hand side of the drawing into sharper focus, including the weight-bearing buttock and the outer edge of the torso. Extend the muscle "ropes" to the base of the skull, and model the head further. Work down the right-hand side of the torso to draw the back-ground and easel, in this way defining the torso's outer edge.

8 As the drawing progresses, the figure will gradually relax into the pose, and if a break is needed it will be almost impossible to revert to exactly the same stance, so expect and allow for slight changes. Mix the hues of the pencils with each other to give a wide range of tone and color, using the Light Blue and Raw Sienna to give a greenish hue, and the Light Blue to sharpen the pink areas.

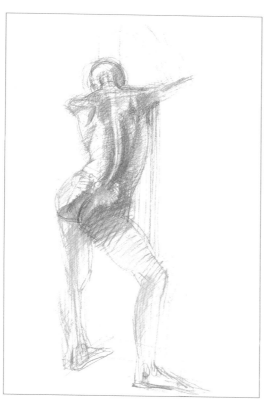

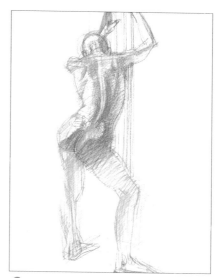

9 Refine and restate the spine, and develop the drawing of both arms—as with the feet, pay careful attention to their relationship to each other, as well as to each one individually.

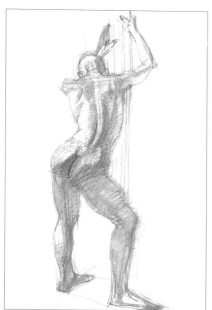

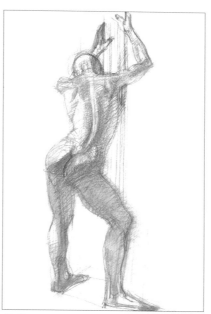

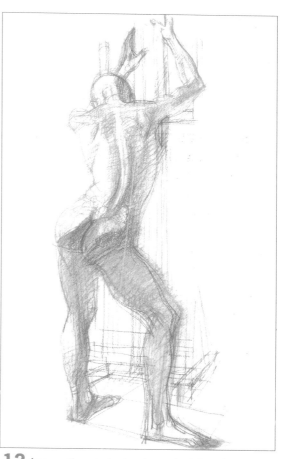

10 Extend the drawing of the legs, taking care to render the cylindrical modeling accurately. Note how the weight-bearing leg, on which so much of the attitude of this pose depends, is much more vigorously defined than the comparatively loosely drawn right leg.

11 Using a small mirror, go over the whole drawing to check the pose, correcting where necessary. Check the color too, and amend this where you consider it necessary.

12 Assess the whole drawing—don't be afraid to make some strong drawing statements if some of the original strength of draftsmanship has been lost along the way. Add more lines to the easel, giving a framework for the figure. Use fixative to protect.

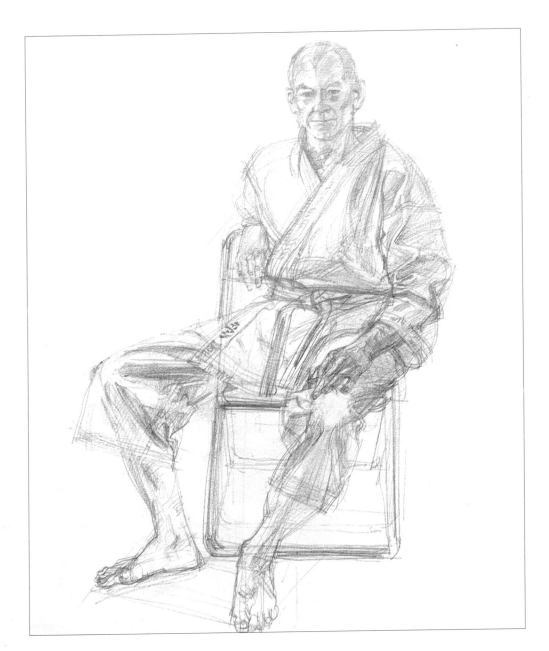

Clothed, Seated Figure

*When drawing a seated figure, it is helpful to consider
the figure and the support as parts of the same structure.*

SEE ALSO:

Even if the chair is largely obscured, you need to be conscious of its weight-supporting function and the shape of its contact with the floor. Also you must not forget that there is a body inside the clothing. Even when the figure is at rest, tensions are created in cloth by bending of the limbs and by gravity.

When an arm or a leg is bent inside a tube of clothing, the cloth is pulled taut over the elbow or knee, while excess cloth on the inside of the bend will fold upon itself. The combination of diagonal pulls and convoluted bunching is typical.

A different pattern is seen when cloth is pulled by gravity from a point of tension, a shoulder for example. Try to express these dynamics, and the clothing will give a strong suggestion of the body beneath, and also help clarify the pose. Drawing fabric on gesso creates interesting effects. See box on p.139.

Materials

5H pencil

Drawing paper sized
 with gesso

Soft putty eraser

1 Plot an imaginary frame around the knees and feet, giving their spatial relationship to the floor plane. Plot further points all around the pose, such as the line of the sitter's left foot and his right shoulder.

2 Having established the overall shape of the drawing, I started to work on the head and its relationship to the torso, using triangulations such as from the top of the head to the outermost points of a curved line drawn through the shoulders. Reduce any incorrectly drawn lines by rubbing with a finger and cleaning up with a putty eraser.

3 Working down the drawing, position the major outlines of the crisp edges of the robe, and plot the positions of both hands. I avoided drawing too much detail of the fabric's folds at this stage—they will change as the sitter relaxes—certain elements, however, such as the reinforced outer edges of the robe, may remain reasonably constant.

4 Constantly reassess the proportions and relationships of the different elements to each other. Draw the position of the right knee using a triangle created by the tip of the knee, the nearest hip and the shoulder above. Work across the drawing, and develop the drawing of the other knee and the hand resting on it.

5 Add detail to the legs, feet and pants. Look out for features, such as the seams and smocking around the costume's edges that act as visible contour lines—when drawn, these convey the three-dimensional form of the clothing. When drawing a leg, imagine the unseen limb inside the costume, and the way in which it affects the shape of the material.

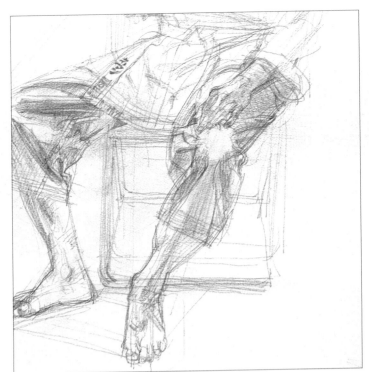

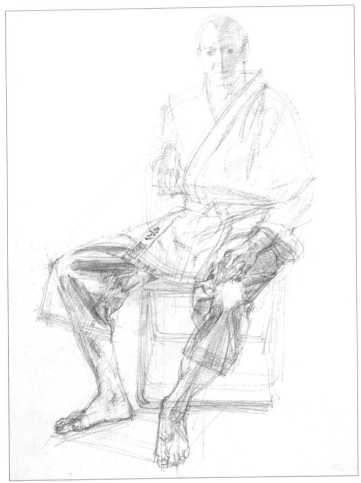

6 Clothing will sometimes reveal anatomy and at other times obscure it. Here, the stiffness of the bottom of the robe and the tied belt hide the shape of the hips and groin. Be aware of the anatomy beneath the clothing, however; otherwise the drawing of the material will appear superficial and unstructured.

7 Now concentrate on details such as the patterns made by the smocking along the robe's opening, giving a quilted, chevron effect. Add shadow detail boldly with the pencil.

8 Add detail to the head and face, and strengthen the line as the drawing becomes more resolved.

9 Concentrate on the folds of the robe that, up until now, may have changed each time the sitter has taken a break. When drawing these details, don't be tempted to slavishly copy the tonal areas, but allow the pencil to explore the shapes of the folds and follow them around as you draw them.

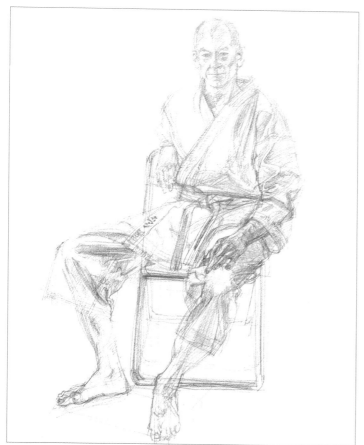

10 I completed the sleeve, and turned my attention to the hand, to resolve this and its relationship to both knee and sleeve. Give a little more definition to the belt and the chair, and use a putty eraser to clean off the redundant triangulation lines.

Pencil on gesso

One of the interesting qualities of working in pencil on gesso is the way that the areas of tone reveal the texture of the gesso's surface. This is particularly suitable when drawing fabric. What is surprising is that this surface texture does not in any way prevent you from rendering in very fine detail when required.

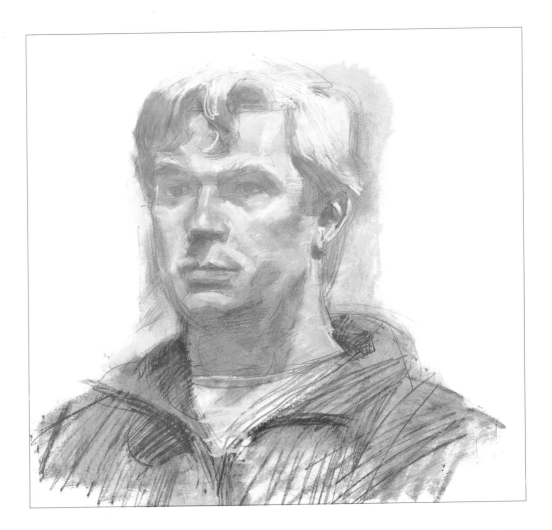

Portrait Head

There is a common misconception that capturing a likeness in portraiture is just a matter of depicting the mobile features correctly.

SEE ALSO:

• Rounded objects with tone,
 page 26

• Using color,
 page 42

• Strong, direct light,
 page 44

It is true that in social intercourse we look at and gain cues principally from the eyes and mouth. However, in order to check for recognition of a familiar face we subconsciously search for quite different, more abstract, information.

Even if the individual features of eyes, nose and mouth are indistinct to the point of being indecipherable, there is no difficulty in recognizing a known face. It is the overall pattern of a human face, the spaces between the features, that confirms the identity. Considering how many individual faces each one of us can recognize, and how similar is the basic pattern, it is clear that we have an astonishing ability to differentiate tiny variations. It is first necessary to find that pattern, to place the features in relationship to each other, to achieve the same likeness in a drawing. Even small variations may prejudice recognition.

Unlike the rest of the body, the surface form of the head and face largely reflects the shape and volume of the underlying bony structure, and you will find it easier to place the features if you try to visualize the forms of the skull and lower jaw. Draw the forms of the forehead, the cheekbones, the brow ridges and the jaw line, and you will have a strong framework for the details.

Materials

Paperboard

Oil bars:
Raw Sienna, Naples
Yellow, Mars Red,
Manganese Blue

Craft knife

Rag

Turpentine or mineral spirits

Graphite stick

1 Sharpen the oil bars by cutting them to a rough point with a craft knife. Using the Raw Sienna bar, loosely sketch in the main areas of tone, putting down enough of the oil bar to work with later.

2 Dip the rag in the turpentine, and rub these tonal areas to soften them. The first traces of the structure of the underlying skull begin to emerge.

3 With the Naples Yellow, begin loosely to draw in more tonal areas, in a similar fashion to step 1.

4 Again soften off the drawing using the soaked rag, making no attempt to establish any detail of the features.

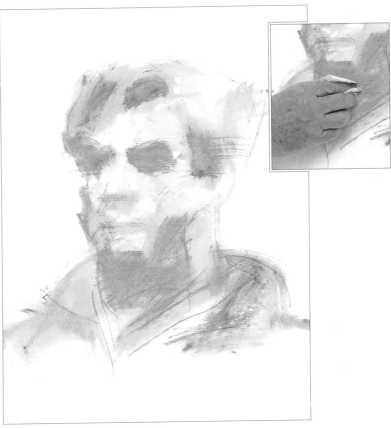

5 Draw over the loose tone with the graphite stick sharpened to a broad wedge, to discover the subject's main features and head structure. At this stage you can remove any marks by rubbing them with a finger or the soaked rag.

6 Work over the graphite with the Raw Sienna oil bar, giving a darker brown element to the drawing.
Inset: Soften this with the rag.

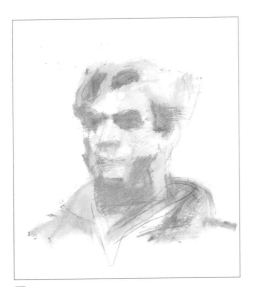

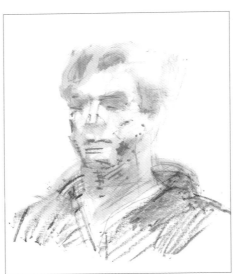

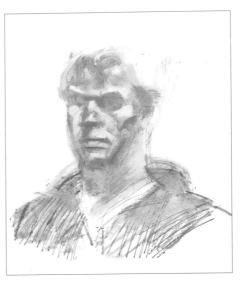

7 Use the graphite stick to establish the position of the eyes. Lightly draw the inverted triangle formed by the center of the two eyes in the corners of the triangle's upturned base, and the inverted apex hitting the middle of the upper lip.

8 With the Mars Red, work into the yellow tones of the drawing to get closer to a convincing flesh tone. Make simple marks with the stick, and also fill in the area of the clothing with Manganese Blue.

9 Again soften the drawing with the rag. With this particular technique there is always an element of loss and gain—each time you soften the drawing, a little of the previous drawing is lost, but this can be redrawn.

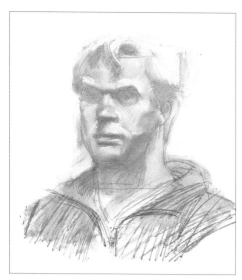

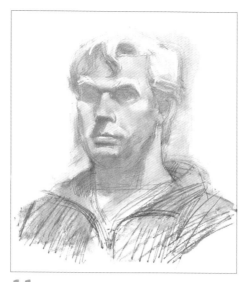

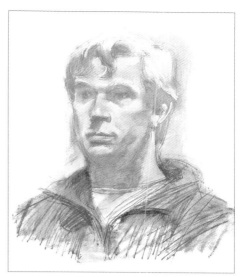

10 Use the graphite stick to darken the shades of the oil bars. To revert to a lighter tone, use a clean piece of rag and fresh turpentine. Add more graphite work, and build up the lighter tones with Naples Yellow.

11 Use the whole range of oil bars to refine the tones and colors of the lower half of the face, and use another piece of soaked rag to moderate the more extreme tonal areas. Add background tone with Raw Sienna, and soften this off.

12 Here I gave the drawing a major assessment and made any adjustments—with oil bars, there is no point at which it is impossible to make corrections.

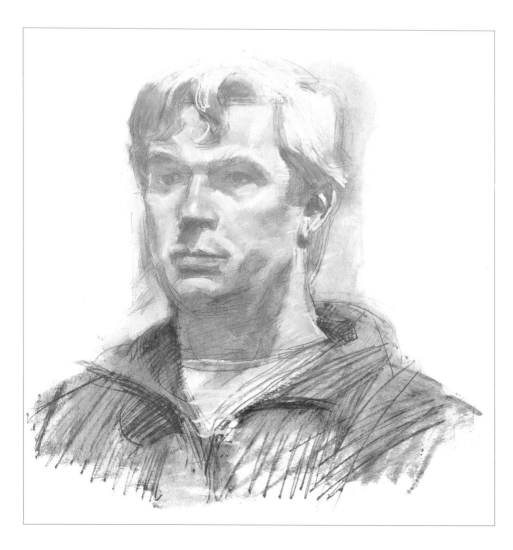

13 With the lightest-toned oil bar, the Naples Yellow, work over the whole drawing, sharpening up the major highlights. Crisp up the darker tones with the graphite stick.

Group Portrait

Undertaking a group portrait may be a rather frightening prospect for the beginner or inexperienced artist.

But never fear—jumping in with both feet, if it does not always result in a wonderful drawing, or even a tolerable one, is always a learning experience. There is no more effective way of learning to draw than actually doing it—practice, as in so many other activities, really does make perfect.

A group that includes children presents the further difficulty that it is unusual to find youngsters who are content to stay still long enough for you to complete any more than the most rapid and cursory sketch. If the group incorporates, or is comprised of children older than, say, six or seven years, and they are not actually interlocked in any way, it may be possible to do a very quick sketch to establish their placings, and then to ask each one to pose in sequence.

For a little girl sitting on her mother's lap, as here, there is really a need to use photography. In some quarters you will find huge antagonism to the use of photographs as reference for drawing—despite the fact that as soon as photography was generally available a large number of serious artists used it, to a greater or lesser extent.

My feeling about photography is that it is just another method of gathering information, with the obvious advantage of speed and accuracy, but with some shortcomings. The most serious is that it only records the fall of light—you can only deduce the three-dimensional form, you cannot see it. The camera has made the selection and has left you with no choices. Only after considerable experience of drawing directly from life can you make proper use of the information recorded by a camera. The worst result—what I would consider to be improper use of the photograph—would be a drawn facsimile, which would also be pointless.

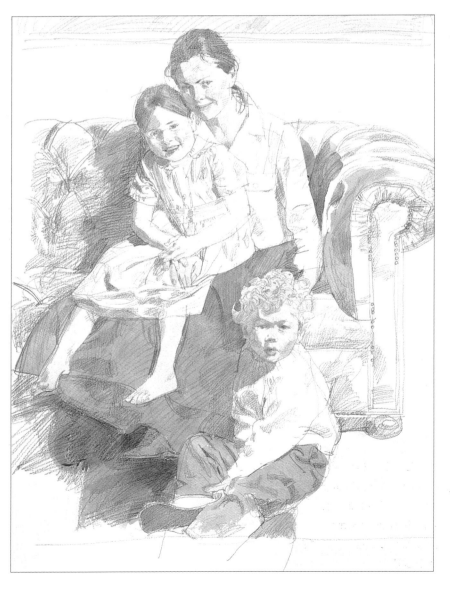

Materials

2B pencil

Rough watercolor
 paper (stretched)

Fixative

Clean water

Medium squirrel-hair
 brushes

Watercolors:
 Vermillion,
 Cadmium Orange,
 Raw Sienna, Burnt
 Sienna, Ultramarine,
 Payne's Gray,
 Lamp Black

1 Using the pencil, lightly sketch in the major outlines of the elements within the composition. Plot the elements, such as the way that a line through the girl's eyes would continue just under her mother's lips, and the inner edge of her left arm (on the right in the drawing) coincides with the space between their faces and is also parallel with both their faces' center lines.

2 Draw the mother's face in some detail. When someone is looking to one side at something close to them, the pupil of their farthest eye is closer to the inner edge of the closest eye than the pupil of the closest eye. This is because the sight lines are converging, not parallel.

3 Work in similar detail on the head of the young girl. Indicate bright highlights, such as the one on the tip of her nose, by simply drawing their perimeters in line. This will look less mechanical when the washes are added.

4 Move onto the girl's dress, paying special attention to the stress and pulls of the folds of the cloth.

5 I added the small boy to the overall image by establishing the face's main features. The proportions of a young child's face are not the same as an adult's—the inverted triangle formed by joining the two eyes and running these points down to the middle of the upper lip is much shallower in the child, and in this case is close to an equilateral triangle.

6 Having established all three figures in the drawing, return to the mother and work in some details of the clothing. Establish the form of the leather sofa to further advance the composition.

7 Add further work on the darker tones, using the pencil in a bolder fashion to achieve richer shades of near black in the sofa's leather buttoning. Work on the mother's skirt, and use pencil shading to indicate both shadow areas and color tone.

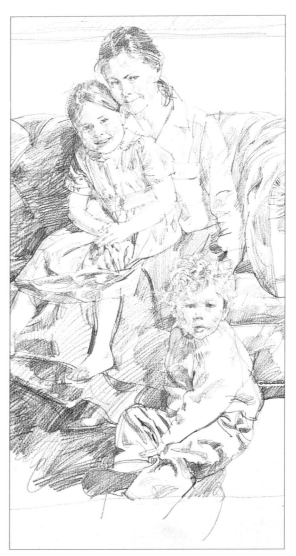

8 Resolve the details of the sitting boy's facial features and hair, and add to the mother's skirt behind him, giving him greater definition. In drawing his shirt, reflect the soft, woollen material with its gentle folds, unlike the crisper creases in the mother's cotton blouse and daughter's dress. Add the details, and strengthen the drawing as you work down, stressing the foreground detail.

9 Use fixative to protect the pencil drawing, then apply a very watery Cadmium Orange wash over all the flesh areas. Add a flesh-colored wash over all the skin areas using a mix of Vermilion, Raw Sienna and Payne's Gray. Flow a light brown wash of Burnt Sienna with a little Black over the mother's hair, and repeat with a paler blonde wash for the daughter. Color the mother's skirt with a mid-tone, blue-gray wash made from Payne's Gray and Ultramarine, and use a slightly grayer version of this to lay down the tones of all the cast shadows.

10 Add a darker flesh tone to cover the shadow areas of the exposed skin, reinforcing the pencil modeling, and use a slightly lighter version on the boy's hair. While these are drying, apply a tan wash of Burnt Sienna to areas of the leather sofa, and a very pale wash to define the upper part of the wall.

11 Put a dark, neutral tone, made from Black and a little Burnt Sienna, over the shadow area at the base of the mother's skirt before using a pinker flesh tone (sharpened with extra Vermilion) to define the lips of each of the subjects, and add warmth to the boy's cheeks. Run a simple wash over his pants before giving a tiny amount of pale blue to all of their eyes, to give them life and coloration.

Sketchbook

It may seem to be rather late in the book to exhort you to keep a sketchbook by you at all times, but it is nonetheless important.

Nothing improves drawing so much as doing it—the more you draw, the more natural it becomes to describe everything in visual terms. A certain amount of self-discipline is required to carry a sketchbook everywhere you go, and even more to draw in it at every opportunity. There is always more time than you might think, and even if you can only make a few marks it is surprising how much can be deduced from them later.

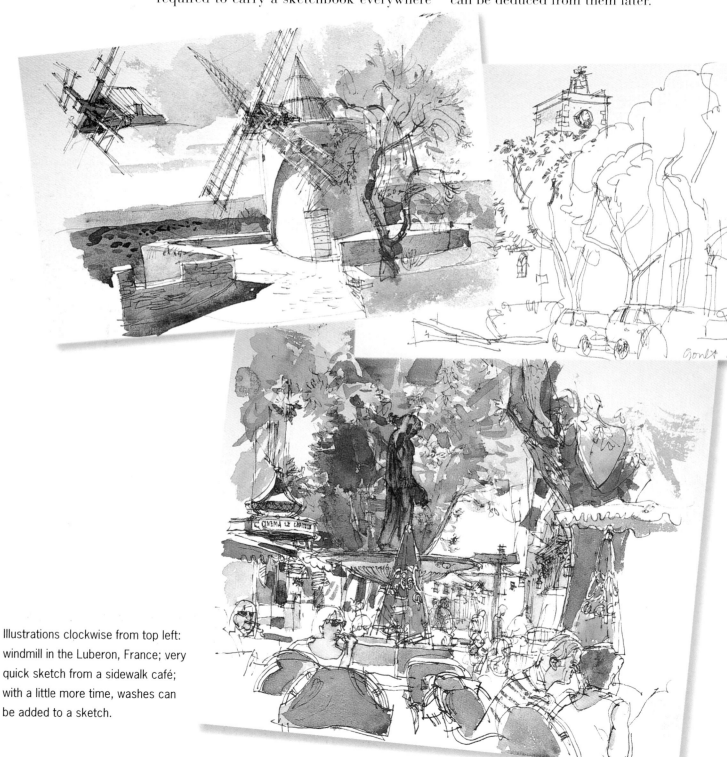

Illustrations clockwise from top left: windmill in the Luberon, France; very quick sketch from a sidewalk café; with a little more time, washes can be added to a sketch.

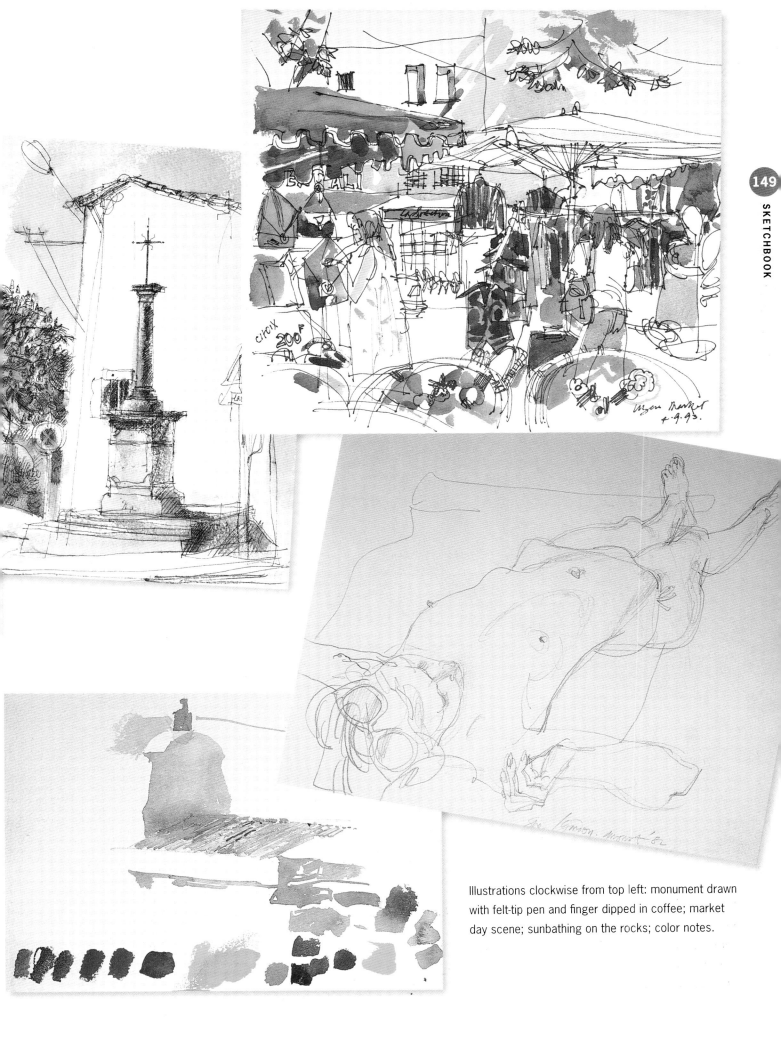

Illustrations clockwise from top left: monument drawn with felt-tip pen and finger dipped in coffee; market day scene; sunbathing on the rocks; color notes.

Cutting out and Patching

However careful you are—and you should not be too careful!—there will be times when a drawing goes too far, or has errors that can't be corrected.

Materials

Paper of similar type
 to that used for
 existing drawing
Hobby or craft knife
Painter's tape

When you are sure that no further progress or corrections can be made, often the best answer is to abandon the drawing and begin again. Do not destroy the drawing—it is astonishing how often a drawing that had seemed to be a complete failure at the time is found to have some value when you look at it again. At worst, it can provide a standard for comparison at a later date.

There are, however, occasions when a drawing can be saved by making a patch to go over an offending area so you can't see the mistake. There are several ways of doing this, the general principle being to contrive to make the edges of the patch follow existing lines or demarcations of tone—all the better if this means several twists and turns resulting in an irregular shape. Thinning the edges of the patch with fine abrasive paper makes it less visible.

Probably the most eye-deceiving way to patch a section of drawing is to cut the rejected section out completely, and replace it with an exactly fitting piece of identical material upon which the new version is then drawn. If you follow the procedure shown, such patching can be almost impossible to detect. On the other hand, you may prefer not to conceal the patch at all, but to treat the additions openly as collage.

1 Lightly tape a piece of paper of similar type under the area to be replaced, then cut round a shape, following an existing pen line where possible. Use a sharp hobby or craft knife for this, cutting through the top layer and the paper beneath at the same time to make a perfect match.

2 Now strip out the top layer, revealing an exactly fitting new piece of white paper.

3 Turn the sheet of paper over, and fix the new piece in place with painter's tape. The patch here has a slightly different color, to make it easier to see, but of course the new piece should be exactly the same color as the paper it is replacing.

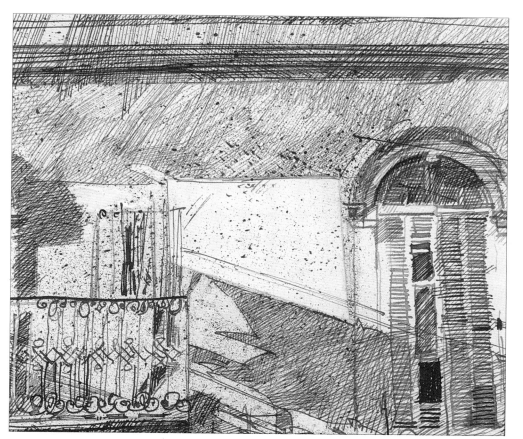

4 Add a more satisfactory drawing to the replacement piece, to resemble other areas of the drawing. (See step 10 inset and step 11 on page 119.)

Extending and Obliterating

Always be prepared to add paper if your drawing becomes too big; artists have been known to add sheet after sheet, ending up with a drawing many times larger than they originally intended.

In addition to cutting out elements of a drawing that may have gone wrong, you can also add pieces of paper to extend a drawing if you find it growing beyond the limits of the sheet.

When normal erasure is not possible, and you prefer not to cut out or add on a patch, you can make corrections by obliterating the rejected sections. Otherwise, indelible marks on paper with no coating can be removed by gentle scraping with a rounded sharp edge like that on a surgical scalpel, but it is difficult to avoid damaging the fibers and rendering the surface too rough and unpredictable for redrawing. For clean and easy scraping, there needs to be a coating such as china clay on the surface, whose top layer can be removed without exposing the support.

Materials

Paper of similar type
 to that used for
 existing drawing
Hobby or craft knife
Gesso
Household bleach
Old brush

1 It is better to add a clearly visible extra piece of paper than to try to squash the drawing into a space that is too small. This is exactly what happened here. The two pieces of paper are separated to show how much of the drawing had spilled onto the new piece.

2 To make an overdraw like this virtually invisible, cut off the underlying extension with a knife and straight edge, butted edge to edge and fixed from underneath with adhesive tape.

1 Commercially prepared, coated paper is unlikely to have a thick enough coating to allow you to scrape back cleanly more than once, but you can prepare a surface of your own with a gesso or similar paint ground of whatever thickness you like, allowing you to scrape away quite vigorously.

2 An advantage of this type of ground is that even if scraped right through to the paper or board beneath, it can be repaired by repainting with more of the same. If the new surface achieved by painting out is very different from the original surface, it may not take the chosen medium in the same way. And of course, if the drawing is on a colored ground, this must be matched by the painting out. Waterproof ink can often be made to disappear miraculously by the use of household bleach applied with a brush, or even with a pen.

Framing a Drawing

A clean, sharply cut mat (mount) can be enormously beneficial to the impact of a drawing. It provides a neutral zone separating the drawing from what may be distracting surroundings.

There are many mat (mount) cutters available nowadays—large, professional ones can be very expensive and only worthwhile if your primary business is picture framing, but for framing just your own drawings, you should be able to find simple, relatively inexpensive hand devices that work well.

Mat (mount) cutters usually take the form of a single-edge blade held at an angle of 45° in a spring-loaded clamp. The blade can be pressed into the mat (mount) board and pushed along a straight edge, invariably cutting from the reverse side of the board, hiding all the measurements and ensuring a clean cut on the top side. It sounds complicated, but as long as the product instructions are followed, it is quite easy to master the action.

You will need a triangle (set square) to ensure right angles in your drawn window, though how you relate your drawn guide lines to the dimensions of the aperture will depend on the design of the particular mat (mount) cutter purchased. The other essential requirement is a good, non-slip straight edge, preferably with a steel edge and a raised protection molding so that you can use it for guiding a craft knife safely when trimming the mat (mount) board to size.

Materials

Mat (mount) cutter

Triangle (set square)

Steel-edged rule
 with raised molding

1 The mat (mount) cutter here requires the guide lines to be drawn exactly the same size as the required window—other designs may instruct you to draw the guide rectangle a little larger than the window to be cut. Aim to position the window closer to the top edge of the whole mat (mount) than to the bottom. Use a triangle (set square) to ensure a right angle between the first two lines, and mark off the dimensions from this.

2 To make the cut, consult the instructions for your specific model. Here, you need to reverse the straight edge and use the wooden part as a guide for the mat (mount) cutter. To ensure that the cut exits cleanly on the top side, always place an offcut of mat (mount) board under the mat (mount) that is being cut.

3 If you have cut it correctly, the center of the board should drop out as you lift the mat (mount) away. If any part of the cut resists this, do not force it—replace everything carefully, and try the cuts again.

4 Turning the mat (mount) over, you should see a clean bevel cut with perfect corners. The bevel edge often displays a contrasting core. For a luxurious double mat (mount), cut a second mat (mount) in the same or a different color, 3/8″ (10mm) or so smaller in each dimension, and combine it with the first one.

Index

Acknowledgements

Thank you to the models who featured in this book: Valerie Sangster, Tom Bristow, Suzi Withington, Charles Clifton, Nigel Sellwood and Jane, Giselle and Joseph Clynick.

With thanks to Roger Bristow for assisting with the step-by-step captions, encouraging and keeping track. Liz Wiffen and Emma Baxter for their design and editorial expertise and patience. My wife, Sheila for sustaining me and tolerating my long absences in front of easel and word processor. Our son Jody for dealing calmly with my many computer crises, assisting with photography and helping with some of the step-by-step captions.